2⁰⁰

D0707513

Giambattista Tiepolo

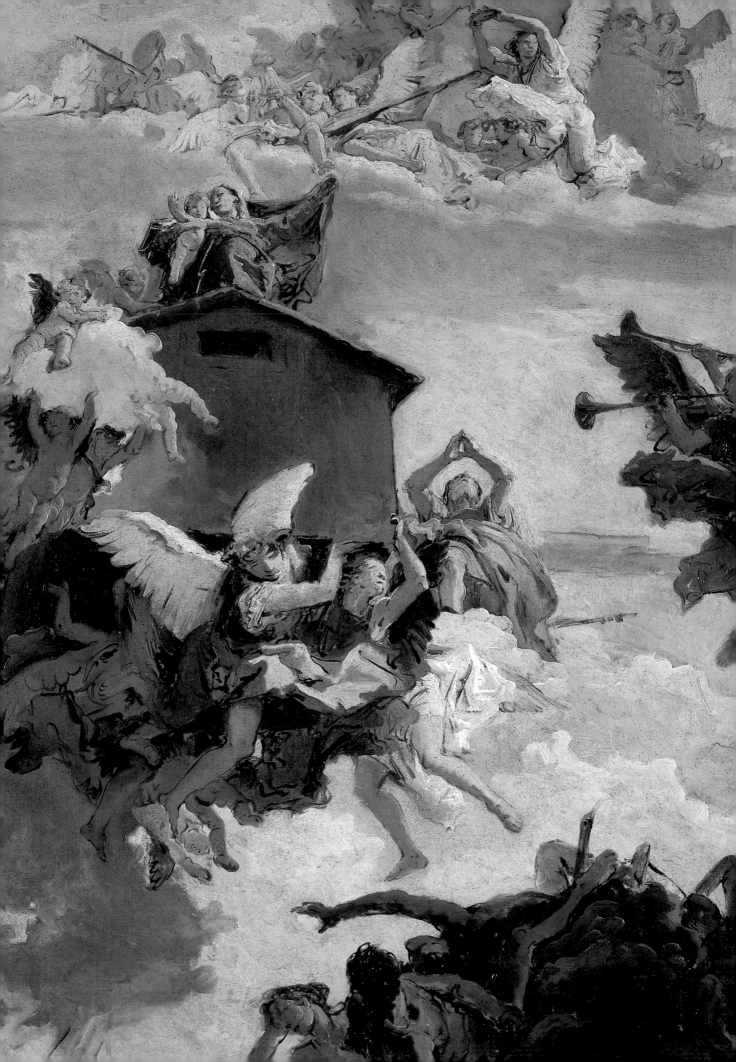

Fifteen Oil Sketches

Giambattista
Tiepolo

Jon L. Seydl

The J. Paul Getty Museum, Los Angeles

© 2005 J. Paul Getty Trust

This publication is issued in conjunction
with the exhibition *For Your Approval:
Oil Sketches by Tiepolo* held at the J. Paul
Getty Museum, May 3–September 4, 2005.

Getty Publications
1200 Getty Center Drive, Suite 500
Los Angeles, California 90049-1682
www.getty.edu

Christopher Hudson, *Publisher*
Mark Greenberg, *Editor in Chief*

John Harris, *Editor*
Jeffrey Cohen, *Designer*
Suzanne Watson, *Production Coordinator*
Cecily Gardner, *Photo Researcher*
Kathleen Preciado, *Indexer*

Color separations by Professional
Graphics Inc., Rockford, Illinois
Printed by Colornet Press,
Los Angeles, California
Bound by Roswell Bookbinding,
Phoenix, Arizona

Unless otherwise specified, all photographs
are courtesy of the institution owning the
work illustrated.

Library of Congress
Cataloging-in-Publication Data

Seydl, Jon L., 1969–
 Giambattista Tiepolo: fifteen oil sketches /
Jon L. Seydl
 p. cm.
 "This publication is issued in conjunction
with the exhibition, For your approval:
oil sketches by Tiepolo, held at the J. Paul
Getty Museum, May 3–September 4, 2005."
 Includes bibliographical references and
index.
 ISBN-13: 978-0-89236-812-9 (pbk.)
 ISBN-10: 0-89236-812-8 (pbk.)
 1. Tiepolo, Giovanni Battista, 1696–1770
—Exhibitions. 2. Artists' preparatory
studies—Italy—Exhibitions. 3. Art—
England—London—Exhibitions.
4. Courtauld Institute of Art—Exhibitions.
I. Tiepolo, Giovanni Battista, 1696–1770.
II. J. Paul Getty Museum. III. Title.
 ND623.T5A4 2005
 759.5—dc22
 2004021141

Front cover: *Saint Luigi Gonzaga in Glory*
(detail). See cat. no. 3.

Back cover: *The Immaculate Conception.*
See cat. no. 10.

Frontispiece: *The Translation of the Holy House
of Loreto* (detail). See cat. no. 8.

CONTENTS

FOREWORD

In 2002, the J. Paul Getty Trust and the Courtauld Institute of Art in London inaugurated a close partnership. This collaborative venture has brought the staff and collections of both institutions closer together, opening the door to exciting projects and bringing important works of art to Southern California. Over the past two years, the Courtauld has allowed a number of masterworks to travel from London to Los Angeles on short-term loan, where these works are placed in a dialogue with the Getty collections. The present project takes as its point of departure twelve glorious paintings by Giambattista Tiepolo in the Courtauld's collection.

These paintings, assembled by Count Antoine Seilern and donated to the Courtauld in 1978, are a significant and varied collection of the Venetian artist's work. Seilern concentrated on highly refined oil sketches by Tiepolo, works of exceptional quality and in fine condition. They represent the full arc of the artist's long career, ranging from a sketch for the earliest of his major ceiling paintings to the *modelli* for his final great commission, the altarpieces for San Pascual Baylon in Aranjuez, Spain. These paintings—and now this exhibition—present a refined and delectable survey in miniature of this towering eighteenth-century artist's work.

We have augmented the Courtauld's exceptional collection with three examples from the strong Tiepolo holdings in Los Angeles, one work each from the Los Angeles County Museum of Art, the Huntington Art Collections, and the J. Paul Getty Museum. The LACMA and Getty paintings help present a broader range of ceiling sketches, complementing the early Palazzo Sandi sketch from the Courtauld with works from the subsequent two decades. The Huntington canvas, a devotional painting in Tiepolo's Saint Rocco series, sets off the Courtauld's painting of the same subject, demonstrating the depth and invention that Tiepolo brought to these commissions.

The exhibition and this catalogue could not have come into being without the work of Jon L. Seydl, Assistant Curator of Paintings, under the direction of Curator Scott Schaefer. I also thank the Museum's former director, Deborah Gribbon, who supported this project from the very beginning.

Finally, I am grateful to the Samuel Courtauld Trust and the Courtauld Institute of Art—particularly the former director, James Cuno, and the current director, Deborah Swallow—for generously sharing with us such a significant part of their collection and for being such warm and gracious collaborators.

William M. Griswold
Acting Director and Chief Curator
J. Paul Getty Museum

ACKNOWLEDGMENTS

THE OPPORTUNITY TO WORK SO CLOSELY with such beautiful and provocative works of art as the oil sketches by Tiepolo in this exhibition has been a real highlight of my experience at the Getty. This project, moreover, brought me in contact with many gifted colleagues both here in Los Angeles and in London, an equally great pleasure.

An exhibition and catalogue such as this one could not have happened without the collaboration of many willing partners. I am especially grateful to the Courtauld Institute of Art, under the direction of Deborah Swallow, who encouraged the project so warmly, and it has been wonderful to work with such a committed and capable group. Chief among them has been Chief Curator Ernst Vegelin van Claerbergen, who has shepherded and warmly supported this project from the very beginning, kindly opening the Courtauld's storage vault as well as the curatorial and conservation files, answering a constant stream of inquiries, and offering me continuous encouragement. I would also like to offer special thanks to the former director, James Cuno, whose exhortation to produce a meaningful catalogue as a testament to the seriousness of the collaboration between the Getty and the Courtauld came at exactly the right moment in the project.

At the Getty, I am grateful to the Museum's former director, Deborah Gribbon, for her constant support. William Griswold and Mikka Gee Conway spearheaded the collaboration with the Courtauld at this end, making the partnership possible, and Scott Schaefer offered the constant encouragement, perspective, and intellectual energy I needed for the endeavor. Mikka Gee Conway deserves special thanks for her considerable skills in negotiating every complexity with grace, dexterity, and aplomb.

I have depended daily on a wide array of colleagues at both institutions to realize this catalogue and exhibition. At the Courtauld, Julia Banks, Alexandra Gerstein, Emma Hayes, and Jonathan Vickers helped enormously, and at the Getty, I must single out Cherie Chen, Catherine Comeau, Lorraine Forrest, Sally Hibbard, Quincy Houghton, and Amber Keller for making the exhibition happen. Reid Hoffman and Silvina Niepomniszcze developed a stylish, nimble installation befitting Tiepolo, which Bruce Metro's team ably installed. Finally, I would like to offer special thanks to Mari-Tere Alvarez in the Education Department, whose counsel shaped this exhibition, catalogue, and related programs.

It has been a particular joy to work with Getty Publications on this book. Mark Greenberg, Christopher Hudson, and Kara Kirk all played key roles in bringing this catalogue together, and I would especially like to thank John Harris for his patience and deft touch in guiding me through my first publication at the Getty. Kathleen Preciado gave careful attention to bibliographic matters, for which I am grateful, and Cecily Gardner performed the important task of assembling the illustrations. For creating a beautiful volume so in tune with the brio of Tiepolo, I thank Jeffrey Cohen and Suzanne Watson.

Andria Derstein, Christopher Drew Armstrong, and Linda Borean graciously shared aspects of their forthcoming research, and I am also grateful to Denise Allen, Julia Armstrong-Totten, Joseph Baillio, Shelley Bennett, Keith Christiansen, Jay Gam, Jean Linn, J. Patrice Marandel, Melinda McCurdy, Tanya Paul, Audrey Sands, Carol Togneri, Jennifer Vanim, Catherine Whistler, and Betsy Wiesman. Finally, for their intellectual insights, practical advice, and necessary encouragement, I extend heartfelt thanks to Victoria C. Gardner Coates, Judith Dolkart, Daniel McLean, and Anne Woollett.

JON L. SEYDL
Assistant Curator of Paintings
J. Paul Getty Museum

Introduction

By any account, Giambattista Tiepolo (1696–1770) stands among the most significant artists of the eighteenth century. ♣ One of the most remarkable aspects of this nimble and productive painter was his capacity to work so brilliantly, over a half-century, across so many media and genres, ranging from his modest drawings to the ceiling frescoes for which he is best known today. ♣ Tiepolo's large number of oil sketches exemplify the deft touch, great intellect, and assured handling characteristic of the artist. ♣ Oil sketches—small, rapidly executed paintings that usually preceded a larger composition—were standard European practice by the eighteenth century. ♣ Because of the astonishing variety, invention, visual delight, and bravura technique of these works, the Venetian artist remains—alongside Peter Paul Rubens— the most memorable practitioner of this type of painting.

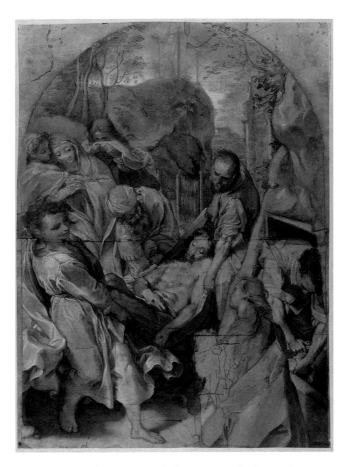

FIGURE A Federico Barocci (Italian, 1528–1612). *The Entombment,*
ca. 1579–82. Black chalk and oil paint on oiled paper. Los Angeles,
J. Paul Getty Museum, 85.GG.26.

The History of Oil Sketches

The oil sketch emerged from the Renaissance tradition of preparatory
studies.[1] Painters customarily used drawings to plan a composition, but
they also often painted a subsequent sketchy draft on the support, a practice
described by such authors as Giorgio Vasari and Ludovico Dolci in their
sixteenth-century treatises on painting.[2] The notion of a small, painted pre-
paratory work on a separate panel, canvas, or sheet of paper first emerged
among the most idiosyncratic sixteenth-century artists of Tuscany and Rome.
These artists—such as Polidoro da Caravaggio, Domenico Beccafumi, and
Federico Barocci (fig. A)—used these sketches to plot the effects of color
and chiaroscuro in their final compositions.

A broader change in artistic practice emerged in earnest in the late six-
teenth century among Venetian artists, including Veronese, Tintoretto, and
Palma il Giovane. In keeping with Venetian tradition, these painters grounded
their works in color as much as line, and the oil sketch placed equal empha-
sis on color relationships in the early development of a composition. These
Venetian artists developed a distinct language of sketchy, assured handling

FIGURE B Jean Joseph-Xavier Bidauld (French, 1758–1846). *View of a Bridge and the Town of Cava, Kingdom of Naples*, 1785. Oil on paper mounted on canvas. Los Angeles, J. Paul Getty Museum, 2001.55.

for these paintings, in which form grew out of juxtapositions of color rather than line, a way of painting that came to characterize the oil sketch.[3]

At this early stage, oil sketches were not part of general teaching practice, and painters did not employ them consistently. Many artists continued to sketch in paint only as the underlayer for the final, finished work. Significantly, painters used oil sketches to develop religious or history paintings—the traditionally more challenging and intellectual genres—rather than portraits, still lifes, or landscapes. (Oil sketches for these genres, especially landscape, would only emerge in the late eighteenth century [fig. B].) The seventeenth- and eighteenth-century oil sketch was thus much more closely linked to *invenzione*, or the cerebral and creative contribution of the artist, than to the spontaneous observation of nature.

Already in the late sixteenth century, artists had begun to use oil sketches to win their patrons' approval for large-scale works, and so these quickly executed paintings became instruments by which a patron could judge the viability of a larger project. This use of oil sketches in turn stemmed from the conditions of patronage emerging in the Counter-Reformation, which called for more careful attention to orthodox iconography and clear visual language.[4]

The oil sketches of Peter Paul Rubens (1577–1640) transformed oil sketches from functional objects, designed to project the form and meaning of the final work, into an independent mode that could itself be appreciated as an independent work of art.[5] Rubens's approach to oil sketches had twin

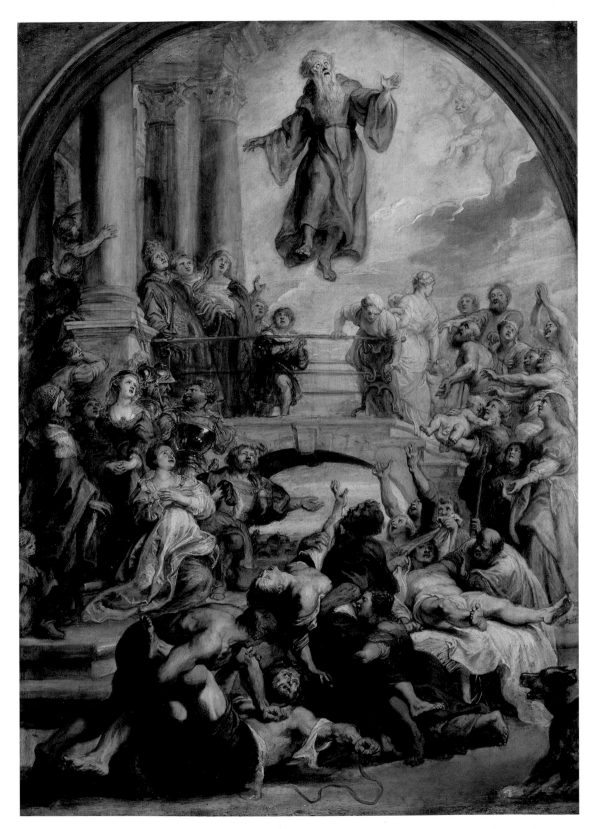

FIGURE C Peter Paul Rubens (Flemish, 1577–1640). *The Miracles of Saint Francis of Paola*, ca. 1627–28. Oil on panel.
Los Angeles, J. Paul Getty Museum, 91.PB.50.

FIGURE D Peter Paul Rubens. *The Meeting of King Ferdinand III of Hungary and the Cardinal-Infante Ferdinand of Spain at Nördlingen*, 1635. Oil on panel. Los Angeles, J. Paul Getty Museum, 87.PB.15.

points of origin: his study with Otto van Veen—the first Flemish artist to paint independent preparatory works—and his later study in Italy. Rubens's sketches stand out from those of his predecessors for their remarkable variation in size, color, degree of finish, use of underdrawing, and support (figs. c–d). As Julius Held has argued, Rubens's sketches were "never bound by fixed rules of procedure,"[6] and he painted them both for patrons and his own use. Rubens clearly thought quite highly of these works: in 1620, the artist jumped at the offer by the patrons of the Jesuit church in Antwerp to keep his thirty-nine sketches for the ceiling in his own possession, in exchange for a new, full-scale altarpiece.[7] Well aware of the value of his sketches, Rubens was the first painter whose oil sketches were collected aggressively during his own lifetime. They were prized not only by other artists but also by a wide range of collectors, not least because of the perception, often quite accurate, that the oil sketch represented the master's undiluted genius, unlike the finished work, which was often painted with studio assistants.

By the eighteenth century the making of oil sketches had become common practice among Italian, French, and Northern artists, who brought these paintings to an extraordinarily high level of refinement.[8] The shift had begun with Rubens; oil sketches were now seen as autonomous works of art and indices of the artist's brilliance and technical skill (figs. e–f). While the practical role of the oil sketch remained constant, artists and collectors increasingly praised the works for their aesthetic qualities. The French critic Denis Diderot extolled these paintings as being a more immediate

FIGURE E
Placido Costanzi
(Italian, ca. 1690–1759).
*The Immaculate
Conception*, ca. 1730.
Oil on canvas.
Los Angeles, J. Paul
Getty Museum,
70.PA.42.

FIGURE F
Pompeo Batoni
(Italian, 1708–1787).
*Christ in Glory with
Saints Celsus,
Julian, Marcionilla,
and Basilissa*, 1736–37.
Oil on canvas.
Los Angeles, J. Paul
Getty Museum,
69.PA.3.

expression of the artist than the artifice of the final composition: "Why does a beautiful sketch please us more than a beautiful picture? It is because there is more life and fewer forms. As one introduces these forms, the life of it disappears."[9] Claude-Henri Watelet's entry on sketches in the *Encyclopédie* (1775) extended this idea even further, seeing in the quick preparation of an oil sketch the mark of genius and individual personality: "It is this rapidity of execution which is the essential principle of the fire one sees ablaze in the esquisses, the sketches, of painters of genius: there one recognizes the mark left by the movement of their soul, one calculates its force and fruitfulness."[10] This increasingly modern critical attitude toward the painted sketch extended to Italy, and the 1731 remarks to Count Giacomo Tassi by Sebastiano Ricci—a painter who particularly influenced the young Tiepolo— have special significance. Ricci argued that the sketch was the primary work of art, with the final composition merely a reflection of the original: "Your Excellency should know that there is a difference between a *bozzetto*, which bears the name of *modello*, and what you will be receiving. Because that is not a mere *modello*, but a completed picture. . . . You should also know that this small one is the original and the altarpiece is the copy."[11] It was from this tradition—surely instilled by Tiepolo's early training with Gregorio Lazzarini as well as close observation of artists such as Ricci and Giovanni Battista Piazzetta—that Tiepolo emerged.

Today we appreciate oil sketches as spontaneous expressions of artistic inspiration, but these works held a complex position in the seventeenth and eighteenth centuries, often functioning simultaneously as artistic tools as well as expressive, collectible works of art. The word *sketch* in English retains this double meaning, on the one hand describing the work's purpose as a preparatory study while on the other referring to a loose and rapid manner of execution. This multivalency also appears in the early terminology describing oil sketches. A vocabulary for these paintings only came into being slowly, with the first terms emerging from the language of drawing, for these paintings were understood initially as a subset of drawing instead of painting.[12] For example, in one of the few references Rubens made to his own sketches, he used the expression "*dissegno colorito*,"[13] derived from *disegno ad olio*, an Italian term for oil sketch used well into the seventeenth century. Rubens's term thus associates the oil sketch with *disegno*, or drawing. In Italian artistic theory, *disegno* refers to the intellectual component of making art, while the adjective *colorito* connects not only to the manual and corporeal aspects of art but also to the senses, indicating that Rubens considered oil sketches a tool to sharpen the intellectual content of a work as well as a concrete way to establish color relationships.[14]

We nowadays distinguish between a *bozzetto*, or an initial idea laid out in paint, and a *modello*, a more elaborate, finished composition used by the artist in developing a larger work, but these terms only began to gain consistent use in the eighteenth century. The Italian *bozzetto* derives from the verbs *abbozzare* and *sbozzare*, words used to describe roughing out a design in paint on a canvas. In actual practice, however, the words were used more loosely, referring to both underpaint and independent preparatory works. In 1681,

Filippo Baldinucci sought to codify these shifting terms in his dictionary *Vocabolario toscano dell'arte del disegno*, reserving *modello* for sculpture and architecture and using *bozza* and *abbozzo* to describe independent oil sketches.[15] Baldinucci used an additional term—*macchia*—to characterize "some drawings, as well as some paintings, made with extraordinary facility, and with harmony and freshness, without much ink or paint, and in such a way that they almost seem not made by the hand of artifice, but as if they appeared by themselves on the page or canvas."[16] The advent of this term thus demonstrates the key shift in the perception of oil sketches in the later seventeenth century. By defining sketches not exclusively by function or medium but by the works' handling and relationship to the artist's mind, critics began to separate the oil sketch from the preliminary drawing and the final painting; ease of handling, freshness, and spontaneous brilliance became the defining and desired qualities.

Tiepolo and the Oil Sketch

At the beginning of Tiepolo's career, oil sketches were standard practice among eighteenth-century Venetian painters, and his zeal for this type of painting was not unusual. Tiepolo's oil sketches, however, stood apart from those of his contemporaries by their assuredness, sophistication, inventiveness, and luxurious handling of paint. These qualities—which remained consistent for over fifty years—derived in part from the innovative way in which Tiepolo conceived of the oil sketch in the overall development of a work. While most eighteenth-century artists began large-scale compositions with preliminary drawings, only eventually working up to a painted oil sketch, Tiepolo reversed that process, beginning major works with an oil sketch and only later using drawings—which ranged from free ink and wash drawings to carefully finished sheets—to develop individual aspects of the entire composition. Likewise, while artists often executed multiple *modelli* for a large project, Tiepolo consistently painted a single complete sketch, rarely revealing palimpsests and overpainting (see cat. no. 12 for an unusual exception). For Tiepolo, the sense of the whole started with exploring color relationships; oil sketches were essential at the inception of a composition.

Despite the clear relationship of oil sketches to drawing, the precise role of these paintings for Tiepolo is not always easy to determine, partly because the sketches could serve multiple purposes over time. Many of the Courtauld paintings were presentation sketches, such as the five *modelli* for the church of San Pascual Baylon in Aranjuez (cat. nos. 9–13), approved by King Charles III of Spain in 1767. With rare exceptions, patrons did not lay claim to these sketches, and they seem to have been perceived, like drawings, as the artist's property.[17] Indeed, the oil sketches consistently remained in Tiepolo's studio throughout the development of the final composition, available for the artist and his assistants to consult. In other cases, especially for ceiling paintings, Tiepolo created sketches with more of an eye to developing the finished composition in relation to the space where the fresco or

altarpiece would eventually be seen. As the Getty *modello* for the ceiling of Santa Maria degli Scalzi (cat. no. 8) demonstrates, oil sketches could even play a role in the dialogue between Tiepolo and other collaborators, such as Girolamo Mingozzi Colonna (ca. 1688–ca. 1766), whose illusionistic architecture often accompanied Tiepolo's frescoes. Works retained by Tiepolo could also enjoy a second life as a salable commodity, such as the sketches sold to the Swedish collector Count Carl Gustav Tessin.[18] He also regularly gave away oil sketches as gifts to clients, colleagues, and friends, such as the works Tiepolo presented to his great advocate, the critic Count Francesco Algarotti.[19]

Sketches made as *ricordi*, or copies after the original composition, remain controversial. That Tiepolo's studio made such copies is not in doubt,[20] but scholars disagree as to whether Tiepolo would have produced such works himself (although the high quality and poised handling of the oil sketch representing a ceiling from the Palazzo Archinto in Milan [cat. no. 4] surely comes from Tiepolo's own hand). At the same time, many *ricordi* are clearly studio copies, exercises Tiepolo—to judge from the number of such works in circulation—enthusiastically encouraged, both as records of projects in far-flung locations and as part of his pupils' education. These copies evidently enjoyed a large resale market, and his sons Giandomenico (1727–1804) and Lorenzo (1736–1772), as well as another pupil, Giovanni Raggi (1712–1792/94), emulated his oil sketches with convincing, salable results.[21]

Collecting Oil Sketches

Most oil sketches—like drawings—remained in painters' studios.[22] These paintings served as pedagogic tools, guides for realizing a larger composition awarded to the studio, or jumping-off points to develop related compositions, practices often continued after the death of the master. Appreciation of oil sketches by art collectors began in the early seventeenth century and swelled over the next two hundred years. The transformation of these paintings from artists' tools to treasured objects was inextricably tied to the growing understanding of oil sketches as distillations of an artist's unique genius. The excitement of the fresh, painterly surfaces became an end in itself, and the works were prized for their closeness to the hand and mind of the artist.[23]

While many collectors competed for oil sketches by Rubens, such broad enthusiasm for *modelli* by other artists remained unusual at the beginning of the seventeenth century, and a small number of figures, such as Carlo, Leopoldo, and Ferdinando de' Medici, as well as Pietro Aldobrandini, dominated the market. Even for these well-known collectors, oil sketches played a relatively minor role in their overall patronage. Symptomatic of this disregard, the seventeenth-century theorist Gian Pietro Bellori ignored oil sketches throughout his *Le vite de' pittori, scultori, e architetti moderni*, even in his biography of Rubens.[24]

Eighteenth-century collectors and dealers sparked interest in the oil sketch, particularly in Venice. This new enthusiasm for *modelli* reflected a

growing taste for a spontaneous style of painting, exemplified by such sophisticated collectors as Tessin and Algarotti, who grouped oil sketches together with loosely painted easel pictures.[25] Oil sketches also proved extremely popular among connoisseurs from the Veneto, such as Giovanni Vianello and Giuseppe Toninotto, who developed important collections of these paintings.[26] The Venetian collector and dealer Giovanni Maria Sasso was the most powerful figure in this shift in taste. His collection included drawings and painted sketches by such artists as Giambattista and Giandomenico Tiepolo, Sebastiano Ricci, Giambattista Pittoni, and Giovanni Battista Piazzetta, and he developed a market for these works, fostering clients in the Veneto and abroad. Recent research on one of these collectors, Sir Abraham Hume, has revealed that for Hume and Sasso the category of *modello* was extremely broad, incorporating oil sketches, colored drawings, and other types of works—including highly polished, reduced copies— indicating the continuing fluidity of the category even into the nineteenth century.[27]

Tiepolo's oil sketches largely remained in his studio throughout his life. Although he occasionally sold these paintings, he bestowed others as gifts, including the Courtauld *Saint Luigi Gonzaga in Glory* (cat. no. 3), which he presented to the family of a recently deceased colleague, indicating that Tiepolo himself valued these works as more than studio tools. Other patrons, notably Algarotti, also commissioned *ricordi* from the artist, although in many cases these paintings came from the studio rather than Tiepolo himself.[28]

Far more oil sketches entered the market after Tiepolo's death in 1770, when his son Giandomenico inherited the numerous remaining paintings and drawings in his father's studio. The Spanish painter Francisco Bayeu owned Tiepolo's sketches for the Aranjuez altarpieces from 1770 until his death in 1795 (cat. nos. 9–13A), suggesting that Giandomenico began selling sketches even before his return to Venice, and he certainly sold paintings to dealers, including Giovanni Maria Sasso.

Giandomenico—who surely used his father's sketches in his own practice as a painter—still owned a substantial number of these sketches even after 1800, to judge from the acquisition of five such works by the sculptor Antonio Canova, including one version of the sketch for the ceiling of Santa Maria degli Scalzi (see cat. no. 5).[29] The dispersion escalated after Giandomenico's death in 1804, when, for example, the Venetian dealer Niccolò Leonelli exported twenty oil sketches by Giambattista Tiepolo to St. Petersburg in 1814.[30]

Tiepolo Oil Sketches at the Courtauld

The remarkable collection of works by Tiepolo at the Courtauld, including the twelve paintings in this exhibition, stand among the signal holdings of the institution. Count Antoine Seilern (1901–1978) assembled these canvases, which form part of his 1978 bequest of 492 works of art to the Courtauld Institute of Art as the Princes Gate Collection.[31] Seilern's

holdings range from the early Italian Renaissance through the mid-twentieth century, but his taste is best characterized by his small, highly refined paintings and drawings that date from the mid-sixteenth through the late eighteenth century.

Seilern began studying art at Vienna University in 1933, and his activities as a serious collector also began around this time. His first scholarly and collecting activities centered on the work of Peter Paul Rubens, and his early absorption in the colorism of this painter foreshadowed his interest in Venetian art (Seilern eventually owned works by Tintoretto, Palma il Vecchio, and Titian) and led directly to his interest in Tiepolo. Seilern bought his first oil sketch by Rubens in 1933, launching a special interest in the working practices of artists. His collection contained numerous examples spanning the history of the oil sketch, including an important early sketch by Polidoro da Caravaggio, as well as striking works by van Dyck, Crayer, Pittoni, and Sebastiano Ricci.

Seilern acquired his first two oil sketches by Tiepolo in 1937 (cat. nos. 9 and 11), and he quickly aimed to create a broad collection of the artist's *modelli*. In some cases, such as the Aranjuez sketches (cat. nos. 9–13A), Seilern sought completeness, acquiring all five painted sketches (and one drawing) by 1967; he always selected pictures of exceptional refinement and quality, advised by the Tiepolo scholar James Byam Shaw. Seilern expanded beyond the category of oil sketches in only two cases, the similarly scaled devotional picture of Saint Rocco (cat. no. 5A) and a small fragment of an altarpiece related to the sketch *Saint Joseph with the Christ Child* (cat. no. 13B).

Seilern produced extensive scholarship on his collection, which survives in the catalogues he published as well as in his extensive notes housed in the Courtauld archives.[32] In these writings, remarkable for their thoroughness and modest, reflective tone, his enthusiasm, knowledge, and prescience reveal a keen understanding and appreciation of the works of Tiepolo. Seilern participated in a larger movement in the mid-twentieth century to recuperate oil sketches not only into the larger understanding of an artist's production but also as a way to understand an artist's work as an active intellectual process.[33] Beyond the radiant beauty of Seilern's oil sketches by Tiepolo, the collection as a whole argues for the artist's intellect, presenting Tiepolo as not only a brilliant technician but an active mind, thoughtfully considering the most suitable form for the complex subjects of these pictures.

1 Our understanding of the role of the early modern oil sketch has been amplified considerably in the past thirty years, thanks especially to the landmark studies of Linda Freeman Bauer and Oreste Ferrari. See especially Linda Freeman Bauer, "On the Origins of the Oil Sketch: Form and Function in Cinquecento Preparatory Techniques," Ph.D. diss., New York University, 1975; Linda Freeman Bauer, "'Quanto si disegna si dipinge ancora': Some Observations on the Oil Sketch," *Storia dell'arte* 32 (1978): 45–57; Oreste Ferrari, *Bozzetti italiani dal manerismo al barocco* (Naples: Electa, 1990); Oreste Ferrari, "The Development of the Oil Sketch in Italy," in Brown 1993, 42–63; and Linda Bauer and George Bauer, "Artists' Inventories and the Language of the Oil Sketch," *Burlington Magazine* 141, no. 1158 (September 1999): 520–30. Other important studies include Bruno Buschart, "Die deutsche Ölskizze des 18. Jahrhunderts als autonomes Kunstwerk," *Münchner Jahrbuch des bildenden Kunst* 15 (1964): 145–76; *Masters of the Loaded Brush: Oil Sketches from Rubens to Tiepolo*, exhibition catalogue (New York: N.p., 1967); and Rüdiger Klessmann, ed., *Beiträge zur Geschichte der Ölskizze von 16. bis zum 18. Jahrhundert*, exhibition catalogue (Braunschweig: Herzog Anton Ulrich-Museum, 1984).

2 Ferrari 1993, 42–43.

3 Bauer 1975, ch. 3; Ferrari 1993, 59.

4 Ferrari 1993, 47–49.

5 The primary source on Rubens oil sketches remains Julius S. Held, *The Oil Sketches of Peter Paul Rubens: A Critical Catalogue*, 2 vols. (Princeton: Princeton University Press, 1980), especially 1:3–18. Also see Peter Sutton and Marjorie Wieseman, *Drawn by the Brush: Oil Sketches by Peter Paul Rubens*, exhibition catalogue (New Haven: Yale University Press, 2004). For an alternative approach to oil sketches in the north, see Ronni Baer, "Rembrandt's Oil Sketches," in *Rembrandt's Journey. Painter—Draftsman—Etcher*, exhibition catalogue, edited by Clifford S. Ackley (Boston: MFA Publications, 2003), 29–44.

6 Held 1980, 4.

7 On the Jesuit church sketches, see Held 1980, 33–62; and John Rupert Martin,

The Ceiling Paintings for the Jesuit Church in Antwerp (London: Phaidon, 1968).

8 For the French tradition of oil sketches, see *French Oil Sketches from the Los Angeles County Museum of Art: Seventeenth Century–Nineteenth Century*. Los Angeles: Ahmanson Foundation, 2002, especially the essay by J. Patrice Marandel, "A Taste for Oil Sketches," ix–xiv.

9 Denis Diderot, *Salons*, 3:1767, edited by Jean Seznec and Jean Adhémar (Oxford: Clarendon Press, 1963), 241: "Pourquoi une belle esquisse nous plaît-elle plus qu'un beau tableau? C'est qu'il y a plus de vie et moins de formes. À mesure qu'on introduit les formes la vie disparaît."

10 "Esquisse," *Encyclopédie ou dictionnaire raisonné des sciences, des arts, et des métiers* (Paris, 1775). Translated in Ferrari 1993, 63.

11 Bottari and Ticozzi 1822, 4:93–94: "Sappia V.S. Ill.ma che vi è differenza da un bozzetto, che porta il nome di modello, è quello che le peverrà. Perché questo non è modello solo, ma quadro terminato . . . sappia di più che questo piccolo è originale e la tavola d'altare è la copia." Translated in Ferrari 1993, 61. Also, consider Ricci's slightly earlier words to Tassi, which indicate the patron's interest in possessing an oil sketch that is a beautiful object in itself: "Il modello della consaputo tavola è terminato; e siccome V.S. illustriss. bramava che fosse più bello della tavola stessa, credo che ne averà l'intento, essendomi veramente riuscito in conformità di quello che bramava" (Bottari and Ticozzi 1822, 4:91).

12 As Linda Bauer and George Bauer (1999) have noted, this phenomenon is consistent across Europe, reflected in the vocabulary in use at the beginning of the seventeenth century: *disegno, dessin,* and *tekeningen.*

13 Peter Paul Rubens to Archduke Albert, March 19, 1614, in *The Letters of Peter Paul Rubens*, translated and edited by Ruth Saunders Magurn (Cambridge, MA: Harvard University Press, 1955), 56.

14 Joanna Woodall, "Drawing in Color," in Cuno 2003, 9–11.

15 Baldinucci 1681. For the complexity of meanings for these terms in seventeenth-century Italy, see especially Bauer and Bauer 1999.

16 "D'alcuni disegni, ed alcuna volta anche pittura, fatte con istraordinaria facilità, e con un tale accordamento e freschezza, senza molta matita o colore, e in tal modo che quasi pare, che ella non da mano d'Artefice, ma da per sè stessa sia apparita sul foglio o su la tela, e dicono: questo è una bella macchia" (Baldinucci 1681, 86).

17 Beverly Louise Brown, "In Search of the *Prima Idea*: The Oil Sketches of Giambattista Tiepolo," in Brown 1993, 19.

18 Brown 1993, 19–20.

19 Levey 1960b, 250–53.

20 Beverly Louise Brown (1993, 17) cites a 1760 letter from Tiepolo to Cardinal Daniele Dolfin in which Tiepolo noted that before the commissioned *modelli* could be sent for inspection, they needed to be copied in the studio.

21 Brown 1993, 18.

22 This phenomenon is well documented from artists' estate inventories. See Ferrari 1993, 56; and especially Linda Freeman Bauer, "Oil Sketches, Unfinished Paintings, and the Inventories of Artists' Estates," in *Light on the Eternal City: Observations and Discoveries in the Art and Architecture of Rome*, edited by Hellmut Hager and Susan Scott Munshower (University Park: Pennsylvania State University, 1987). Linda Bauer notes the considerable semantic challenges in determining from inventories the difference between oil sketches and unfinished paintings. Nonetheless, the inventories appear to be consistently peppered with oil sketches.

23 Bauer 1978, 45.

24 Ferrari 1993, 56; Giovan Pietro Bellori, *Le vite de' pittori, scultori, e architetti moderni*, edited by Evelina Borea (Turin: Giulio Einaudi Editore, 1976); for Rubens see 237–68.

25 Brown 1993, 19–20. For more generally on the taste for loose, painterly brushwork, see Philip Sohm, *Pittoresco: Marco Boschini, His Critics and Their Critiques of Painterly Brushwork in Seventeenth- and Eighteenth-Century Italy* (Cambridge: Cambridge University Press, 1991), especially 1–62.

26 Francis Haskell, *Patrons and Painters: A Study in the Relations between Italian Art and Society in the Age of the Baroque* (New Haven: Yale University Press, 1980), 373–76.

27 I am grateful to Linda Borean for sharing aspects of her important forthcoming study of Sir Abraham Hume, Giovanni Maria Sasso, and Giovanni Antonio Armano, from which these observations derive.

28 Brown 1993, 19–20; Levey 1960b.

29 Pavanello 1996, 7–75. A cousin of Giandomenico, Ferdinando Tonioli, played a key role in the transactions with Canova, further underscoring the importance of family networks in these sales (as well as the popularity of Giambattista Tiepolo's oil sketches among artists).

30 Burton Fredericksen, "Niccolò Leonelli and the Export of Tiepolo Sketches to Russia," *Burlington Magazine* 144, no. 1195 (October 2002): 621–25.

31 This section depends heavily on the important study of Seilern's collection by Helen Braham. See the introduction to Braham 1981, as well as Ernst Vegelin van Claerbergen, "'Everything connected with Rubens interests me': Collecting Rubens' Oil Sketches: The Case of Count Antoine Seilern," in Cuno 2003, 23–30.

32 Seilern 1959; Seilern 1969; Seilern 1971a; Seilern 1971b.

33 Ernst Vegelin van Claerbergen, "'Everything connected with Rubens interests me': Collecting Rubens' Oil Sketches: The Case of Count Antoine Seilern," in Cuno 2003, 26–27.

Catalogue

I *Allegory of the Power of Eloquence*

ca. 1725
Oil on canvas
46.5 × 67.5 cm (18¼ × 26⅝ in.)
The Samuel Courtauld Trust at the Courtauld Institute Gallery,
Courtauld Institute of Art, London; inv. 340

PROVENANCE

Private collection, Madrid;
Hügelshofer, Zurich, by 1955; sold to
Count Antoine Seilern (1901–1978),
London, 1959; by bequest to the Home
House Trustees for the Courtauld
Institute of Art, University of London,
1978.

EXHIBITIONS

None.

BIBLIOGRAPHY

Morassi 1955b, 4–7, figs. 2, 4–6; Piovene
and Pallucchini 1968, 89, fig. 32; Seilern
1969, 27, pl. XXX; Braham 1981,
72, fig. 105; Levey 1986, 23–24, fig. 30;
Farr 1987, 62–63 (illus.); Barcham
1989, 167–68, fig. 97; Bradford and
Braham 1989, 24; Farr, Bradford, and
Braham 1990, 68, 69 (illus.); Brunel
1991, 56 (as "collection privée");
Brown 1993, 201, fig. 89; Gemin and
Pedrocco 1993, 245; Knox 1993, 135–37,
fig. 2; Pedrocco 2002, 208–9, fig. 52.1.a.

THIS PAINTING IS THE INITIAL SKETCH for the ceiling of the main *salone* of the Palazzo Sandi in Venice (fig. 1.1). Tommaso Sandi, a powerful Venetian lawyer, launched a major renovation of the palazzo in 1721 under the direction of the architect Domenico Rossi. Despite a paucity of documentation, scholars have consistently dated the frescoes to 1725–26 for stylistic reasons, placing them between the presumed end of the construction of the palazzo in 1725 and the start of Tiepolo's work in Udine the following year.[1]

The first reference to the fresco, Tiepolo's first major ceiling commission, comes only in 1732, when Vincenzo da Canal described the work as four stories illustrating the power of eloquence.[2] Tiepolo painted several mythological scenes on canvas for the walls below;[3] the comission also involved a collaboration with Nicolò Bambini, who executed the frieze of grotesques beneath the ceiling and the walls and contributed two wall paintings.[4]

In the sketch, Minerva and Mercury—gods of reason, wisdom, and eloquence—preside at center over four mythological scenes that surround the edges of the rectangular canvas. On the right appears a subject well known from such classical sources as Apollodorus's *Library* (3:5:5–6) but unprecedented in painting,

Amphion building the walls of Thebes with his music. Amphion—the son of Zeus and Antiope, the queen of Thebes—was abandoned at birth and raised by shepherds, and through the tutelage of Mercury he became a remarkable musician. When Amphion and his twin brother, Zethus, sought out their mother as adults, they discovered her mistreatment at the hands of their uncle and his wife. Overthrowing Antiope's tormentors, they assumed power over Thebes and sought to fortify the city. Amphion began to play his lyre, and through the sheer power of his music the stones flew through the air and moved into place. As in all the scenes in Tiepolo's sketch, the figures, seen *di sotto in sù*, rise from the cornice line. Amphion stands on an outcrop at left, wrapped in a blue windswept cloak (a detail the artist picked out in lapis, in contrast to the Prussian blue used elsewhere on the canvas). He stands before the viewer, confidently plucking his lyre, and turns back to behold the masonry his music sends flying through the air, constructing a gleaming white fortification, while spectators point, gaping in surprise.

Orpheus claiming Eurydice from Hades appears at bottom. Best known from Ovid's version in the *Metamorphoses* (10:53–63), Orpheus, another remarkable musician trained by Mercury, descended into Hades hoping to reclaim his

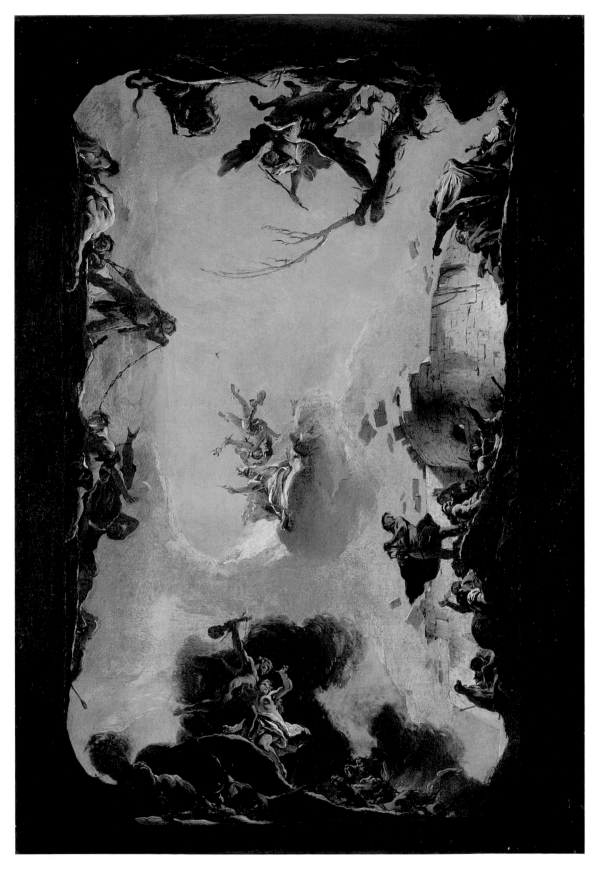

CAT. NO. I

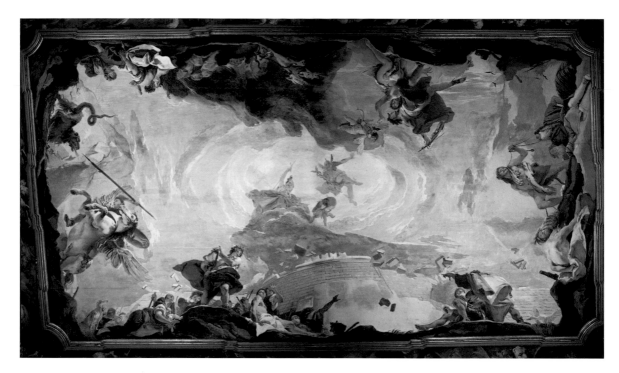

FIGURE 1.1 Giambattista Tiepolo. *Allegory of the Power of Eloquence*, 1725–26. Fresco. Venice, Palazzo Sandi. Photo: Scala/Art Resource, New York.

wife, Eurydice, who had been killed by a snakebite. With music so moving it brought even the Furies to tears, Orpheus persuaded Pluto to release Eurydice, which the god granted on the condition that Orpheus not gaze upon her until he had passed Cerberus at the gates of the underworld. In Tiepolo's sketch, Orpheus—supporting his wife with one hand and raising a stringed instrument with the other—crosses the rocks near the exit of Hades, with its menacing dark cloud, while the three-headed Cerberus barks fiercely in front of them. Tiepolo thus presents the charged moment just before Orpheus, fearing that Eurydice might falter on the rocky path, glances back at his wife and loses her forever.

Across from Amphion appears the strapping figure of Hercules, clad in animal skins, who strides above eight prostrate figures attached to

him by chains. Antonio Morassi, who first published the sketch in 1955, identified this scene as Hercules and the chained Cercopes.[5] The Cercopes were gnomes whom Hercules seized and carried away in chains after they attempted to rob him. Dangling behind his back, the Cercopes joked about their view—Hercules' hairy and sunburned buttocks—and their witty comments caused the hero to laugh so uproariously that he agreed to free them.

While the story lends itself to the overall theme of eloquence, the large crowd of figures, Hercules' lack of amusement, and the position of the chains indicate another story, Hercules Gallicus captivating his audience. This ancient Celtic tradition, first described by Lucian in *Herakles: An Introduction*, casts Hercules, rather than Mercury, as the god of eloquence and

had been represented emblematically by Hercules dragging his listeners with chains attached from his mouth to his audience's ears. Artists such as Albrecht Dürer depicted the story, and it appeared regularly in Renaissance literature, including the widely published *Imagini degli dei degli antichi* of Vincenzo Cartari.[6] Tiepolo, typically, strayed far from the early sources and did a free variation on the print tradition to create an image better suited to an illusionistic ceiling. In the sketch the figures expand horizontally across the ceiling, with Hercules at the acme of a low pyramid of figures. Tiepolo also alters the standard interpretation, depicting the chains attached more plausibly to the hero's neck and hands.

The final image in the sketch depicts a common myth, Bellerophon attacking the monstrous Chimaera while mounted on Pegasus, the flying steed provided him by Minerva. Tiepolo presents the horse and rider at a particularly startling angle, rearing to charge the monster. The subject appears infrequently in painting, and Tiepolo again drew on the emblematic tradition for his imagery: the motif of Bellerophon attacking the Chimaera with a branch derives from a print first published by Andrea Alciati in the sixteenth century.[7]

This composition is the first extant oil sketch by Tiepolo for a ceiling painting and represents an early stage in his development as a ceiling frescoist.[8] He pushes each scene to the margins of the composition, where each pyramidal vignette stands on an independent bit of landscape, in turn connected to the architectural frame of the *salone*, with the sky opening up behind each group. Tiepolo revised this composition considerably in the fresco, most significantly by rearranging the order of the stories, placing Orpheus and Eurydice across from Amphion on the long walls, and placing Bellerophon opposite Hercules Gallicus on the short wall.[9] He also increased the proportions of the figures, highlighting the gods at center through a burst of white light and a whorl of clouds. In painting the ceiling Tiepolo shifted his palette considerably, moving from the warm tones of the sketch (derived from the thin application of paint over the reddish ground) to the bright, saturated colors of the fresco.

Scholars have gradually worked out the interpretation of the ceiling and the sources for the unusual combination of myths. The stories all come from common ancient texts, but the chief sources are emblem books, suggesting a highly literary unifying theme.[10] That theme may have been eloquence, an especially appropriate subject for the Sandi family, who made their fortune through the law and were ennobled in 1685.[11] In this interpretation, Hercules and Amphion directly exemplify eloquence, Orpheus implies it indirectly, and Bellerophon represents the general triumph of civilization and culture.[12] Sandi patronage demands further study and should ultimately provide the key to the program.[13] While the iconography no doubt bears some relation to the legal profession that secured the Sandi their wealth and noble status, the ceiling stands apart from other eighteenth-century Venetian frescoes in not openly glorifying the family name, suggesting a highly specific intellectual program in play.[14]

Music may also be a more important organizing theme than previously acknowledged. In revising the sketch Tiepolo placed the two musical subjects in primary position and substituted a contemporary stringed instrument for Orpheus's traditional lute. While the subjects were all atypical for painters to represent and certainly never appeared together, Amphion, Orpheus, and Bellerophon were all common subjects in early modern music, including celebrated compositions such as Carlo Grossi's chamber work *L'Amphione*, first performed in Venice in 1675; Antonio Draghi's 1682 opera *La Chimera*; Paolo Magni's 1698 opera *L'Amphione*; and Jean-Philippe Rameau's 1721 cantata *Orphée*.[15] ❧

NOTES

1 For detailed analysis of the palazzo and frescoes, see Knox 1993.

2 Vincenzo da Canal, 1732 manuscript published as *Vita di Gregorio Lazzarini* (Vinegia: Palese, 1809), XXXII: "*Dipinse a Venezia nel palazzo Sandi il soffitto della sala in quattro storie indicanti la Eloquenza sotto altri jeroglifici.*"

3 *Achilles among the Daughters of Lycomedes, Apollo and Marsyas,* and *Hercules and Antaeus,* now in the da Schio collection, Castelgomberto, Vicenza.

4 *Veturia and Volumnia Appealing to Coriolanus* and *The Three Graces*, now in the da Schio collection, Castelgomberto, Vicenza.

5 Antonio Morassi (1955b, 4). Bernard Aikema (1986, 171n.11) and Filippo Pedrocco (2002, 280) have reaffirmed this interpretation.

6 Vincenzo Cartari, *Le imagini degli dei degli antichi* (Venice: Vincentio Valgrisi, 1571), 341.

7 Andrea Alciati, *Emblematum liber* (Paris: Christiani Wecheli, 1542), 226–27.

8 Brown 1993, 201.

9 As Antonio Morassi first observed (1955b, 7), Tiepolo probably reworked the Hercules scene much later, perhaps on account of some damage to the original, which explains the more even handling of light and the neater contours of the figures, connected to his much later style, perhaps post-1753.

10 Knox 1993, 135–37.

11 Knox 1993, 135; and Levey 1986, 23.

12 Others have interpreted the theme even more broadly, with Michael Levey (1986, 23) considering the work as centering on the notion of ingenuity. Bernard Aikema (1986, 167), connecting the ceiling with the full decorations for the room, also viewed the ceiling as an *exemplum virtutis* for the marriage of Tommaso Sandi's son, Vettor, in 1724. Aikema's thesis, however, depends on a misreading of the date of the wedding.

13 For example, Christopher Drew Armstrong has proposed an important new interpretation of the iconography, rooted in Giovanni Battista Vico's theories of history and natural law, first outlined in a lecture, "Myth and Enlightenment: Tiepolo and the New Science," University College, University of Toronto, March 17, 2004 (to be published in a forthcoming article). For important insights into the intellectual interests of the Sandi family, see Francesco dalla Colletta, *I principi di storia civile di Vettor Sandi: Diritto, istituzioni, e storia nella Venezia de metà Settecento* (Venice: Istituto veneto di scienza, lettere, e arti, 1995).

14 Knox 1993, 141.

15 See entries in *The Oxford Guide to Classical Mythology in the Arts*. Pegasus held a crucial position in Arcadian poetics, suggesting a possible connection of the Sandi to Arcadian circles. See, for example, Liliana Barroero and Stefano Susinno, "Arcadian Rome: Universal Capital of the Arts," in Bowron and Rishel 2000, 52.

2 The Madonna of the Rosary

ca. 1727–29
Oil on canvas
44.2 × 23.9 cm (17⅜ × 9⅜ in.)
The Samuel Courtauld Trust at the Courtauld Institute Gallery,
Courtauld Institute of Art, London; inv. 341

PROVENANCE

Jaffé, Berlin; private collection, Bergamo, Italy, by 1962–64; sold to Count Antoine Seilern (1901–1978), London, 1964; by bequest to the Home House Trustees for the Courtauld Institute of Art, University of London, 1978.

EXHIBITIONS

Venice and New York 1996, no. 30b.

BIBLIOGRAPHY

Thieme-Becker 1939, 147; Morassi 1962, 4, 19, fig. 80 (as *Madonna and Child with an Angel*); Piovene and Pallucchini 1968, 90–91, fig. 41 (as *Madonna col bambino e un angelo*); Seilern 1969, 28, pl. XXI (as *Madonna and Child with an Angel*); Braham 1981, 73, fig. 107 (as *The Madonna and Child with an Angel*); Barcham 1989, 164, 166, 168, fig. 96 (as *The Madonna and Child with an Angel*); Bradford and Braham 1989, 25 (as *The Madonna and Child with an Angel*); Gemin and Pedrocco 1993, 249, fig. 73 (as *Madonna con bambino e angeli*); Christiansen 1996, 205, 207–8, fig. 30b; Pedrocco 2002, 209, fig. 55 (as *Madonna col bambino e angeli*).

A MONUMENTAL STATUE COME TO LIFE, the Virgin steps forward grandly from a niche, presenting the Christ Child to the beholder while an angel kneels humbly before them. The infant Jesus gazes out with curious intensity, sweetly mimicking the Virgin's stance and her outstretched arm. He stands on a cerulean cloth held by his mother, as well as a cloud supported by two putti. Both mother and son hold rosaries: the Virgin's coral beads flicker in the shadows at right, while Christ's golden rosary gleams brightly, proffered to the viewer.

This work beautifully demonstrates the brilliant technique Tiepolo brought to his oil sketches. The coloristic richness of this painting depends on the artist's deft and economic use of ground layers. Tiepolo prepared the canvas with a warm reddish brown ground, followed by a stratum of cool blue-gray. He then incorporated these layers in the overall palette, using them, for example, to describe the faces and the niche's frieze. Less interested in precise anatomical description than in defining form through color, Tiepolo employed bold passages of wet-on-wet paint, such as the lemon, ice blue, and rust strokes of the angel's shoulder, or the greenish blue reflections of the blue cloth in the cloud and on the white fabric held by the Virgin. Likewise, Tiepolo portrays Mary in a red-orange gown, shot through with bravura strokes of white and canary yellow.

Antonio Morassi first connected the painting to a small altarpiece, documented to 1735 (fig. 2.1).[1] Subsequent scholars have generally agreed that the sketch dates to an earlier mode in Tiepolo's career, around the time of his work in Udine, since the sharp color contrasts and spiky figures recall the artist's early inspiration from Giovanni Battista Piazzetta.[2] Although the altarpiece takes its basic format and color scheme from the oil sketch—particularly in the figure of the statuesque Virgin—the changes between the early painting and the final work are considerable, demonstrating a major stylistic and conceptual break between the two images. The altarpiece strikes a more ecclesiastical note, marked by the angel's transformation into an acolyte carrying an incense burner. It also has a more personal tone, with Tiepolo lowering the viewpoint slightly and placing the Madonna solidly on the ground. Moreover, the final work emphasizes the Madonna's role in presenting the gift of the rosary to humanity, as well as her

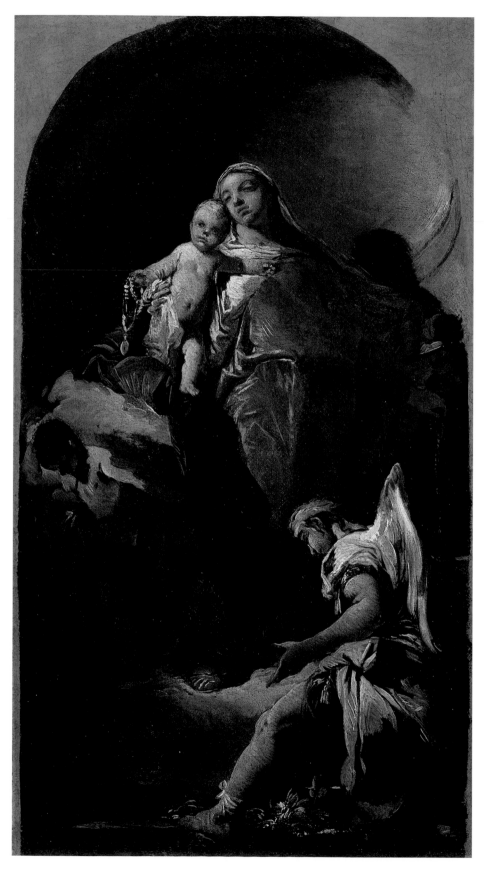

CAT. NO. 2

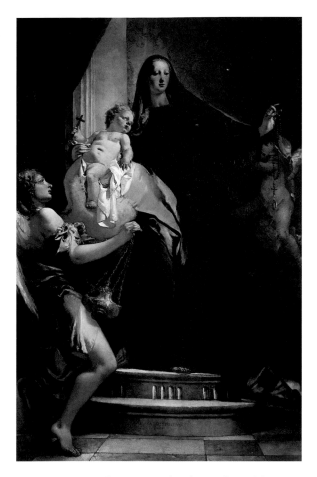

FIGURE 2.1 Giambattista Tiepolo. *The Madonna of the Rosary*, 1735. Oil on canvas. Private collection.

well as the contrast between the tender infant and the grave expression of the Virgin—thus speaks directly to the rosary. According to legend, Saint Dominic (ca. 1170–1221) initiated the practice of the rosary, which he received from the Virgin in a vision. Historically, however, the rosary developed out of Marian devotions in the twelfth century and—influenced by the Dominican order—its use was widespread by the fifteenth century. In the eighteenth century the rosary enjoyed newfound popularity under the Dominican pope Benedict XIII Orsini (r. 1724–30), who extended the feast of the rosary to all Roman Catholics in 1726. For this reason the painting may connect to Dominican patrons, perhaps a Dominican church or a related con-fraternity. Given that the rosary functioned as a means to grace and an instrument of communal, controlled prayer, the image may have partic-ularly appealed to patrons participating in the revival of traditional, Counter-Reformation values in the early eighteenth century.

Certainly the renewed interest in the rosary under Benedict XIII argues for an early dating for the sketch. Tiepolo may well have executed this *modello* on a currently popular devotional theme in the hope of attracting patrons, rather than as a study for a specific commission.[4] He may have turned back to the sketch years later as the jumping-off point for the full-scale altarpiece. ❧

role as intercessor. Tiepolo moves the Virgin's arm forward and picks out her hand with light. All the central figures train their attention on her rosary, and Christ holds a small cross instead of beads. Tiepolo also moves away from the dramatic color relationships and startling con-trasts of light and dark so crucial to the sketch, toward the more even lighting and more blended color scheme that mark the finished work.

The rosary, an exercise in mental and vocal prayer, involves the repetitive recitation of the Hail Mary while meditating on the life of Christ.[3] Mary's centrality in both images—as

NOTES

1 Morassi 1962, 4.
2 The earlier dating was first proposed in Piovene and Pallucchini 1968, 90–91.
3 For more on the connection of the cult of the rosary and the visual arts, see especially Esperanca Maria Camara, "Pictures and Prayers: Madonna of the Rosary Imagery in Post-Tridentine Italy," Ph.D. diss., The Johns Hopkins University, 2003.
4 Entry by Catherine Whistler in Christiansen 1996, 205–8.

3 Saint Luigi Gonzaga in Glory

ca. 1728–29
Oil on canvas
58 × 44.7 cm (22⅞ × 17⅝ in.)
The Samuel Courtauld Trust at the Courtauld Institute Gallery,
Courtauld Institute of Art, London; inv. 170

PROVENANCE

Probably the heirs of Andrea Fantoni
(1659–1734), 1735; by inheritance within
the Fantoni family, Casa Fantoni,
Rovetta, near Bergamo; sold through
W. Burchardt to Count Antoine
Seilern (1901–1978), London, 1953; by
bequest to the Home House Trustees
for the Courtauld Institute of Art,
University of London, 1978.

EXHIBITIONS

London 1954–55, no. 478; London 1960,
no. 411.

BIBLIOGRAPHY

Fiocco 1938, 152; Morassi 1938, 141–42,
frontispiece; Watson 1955, 262, 264,
fig. 298; Seilern 1959, 159, pls. CXXXII,
CXXXIII; Morassi 1962, 20, fig. 113;
Piovene and Pallucchini 1968, 91,
fig. 44; Seilern 1971a, 57; Braham 1981,
73, fig. 106; Martini 1988, 154, no. 10,
fig. 4; Barcham 1989, 164, 168, pl. V;
Bradford and Braham 1989, 25; Farr,
Bradford, and Braham 1990, 72 (illus.);
Gemin and Pedrocco 1993, 249, fig. 74;
Pedrocco 2002, 209, fig. 57.

HELD ALOFT BY A GROUP OF PUTTI, the Host rises on a cloud before Luigi (Aloysius) Gonzaga (1568–1591). The young Jesuit throws his head back and closes his eyes, in the throes of an ecstatic vision. Clad in swirls of fabric, three angels accompany him, and they—along with the putti at lower right—bear garlands, crowns, and scepters, signaling the majesty of the event. The open book on the steps suggests that the young man's prayers have been interrupted, but the event takes place in an entirely fantastic Veronesian setting, conveying the overwhelming grandeur of Luigi Gonzaga's rapture. A sculpture of Faith—the only figure touching the ground in the painting—underscores the profound belief that fuels this vision, but the oil sketch accentuates above all the high emotional key and otherworldliness of the scene. The vivid contrasts of dark and light around the perimeter of the canvas emphasize the spectacular nature of the event, and the peculiar perspective, especially the exaggerated tilt into space created by the pattern of floor tiles, further transports the event into the spiritual, rather than the material, realm. Tiepolo elongates the proportions of all the figures, especially Luigi Gonzaga, emphasizing his slenderness, youth, and overpowering supernatural experience, and the artist intensifies the young man's gray pallor through the intense white of his robe and the spectrum of pinks that appear on the fleshy angels surrounding him.

Born into one of Italy's most illustrious noble families, Luigi Gonzaga came under the spiritual guidance of Charles Borromeo at the age of twelve. In 1585 he renounced his inheritance and entered the Jesuit order in Rome as a novice, energetically devoting himself to Christian service, most remarkably by nursing the sick during the 1591 outbreak of plague in Rome. Always physically weak, Luigi died at the age of twenty-three and immediately became a beloved popular religious figure and one of the best-known Jesuits.

Representations of the saint began to appear frequently in the Veneto during the late 1720s, for example, in altarpieces by Antonio Balestra and Giovanni Battista Piazzetta, an interest surely sparked by his canonization in late 1726 and the 1729 declaration of the saint as patron to youth by Pope Benedict XIII Orsini (r. 1724–30).

In its depiction of a mystical experience, this image stands squarely at the center of fundamental religious debates in eighteenth-century

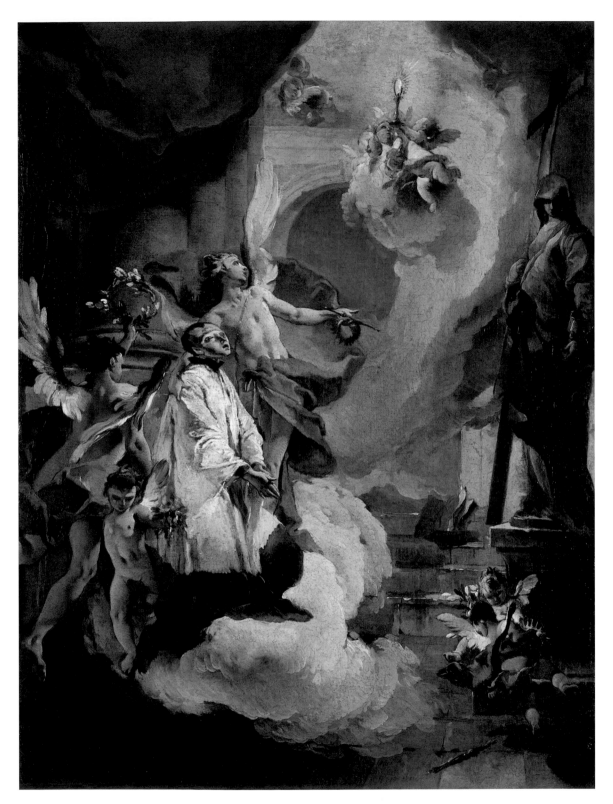

CAT. NO. 3

Italy between advocates of visionary, emotive spirituality and supporters of *regolata devozione*, or the moderated, Enlightenment-influenced movement, supported by such rationalist reformers as Ludovico Antonio Muratori. Tiepolo's altarpiece charts a middle ground, demonstrating the young artist's already keen sensitivity to complex ecclesiastical arguments. Rather than represent a specific moment in the young saint's life, Tiepolo concentrates on Luigi Gonzaga's well-known devotion to the Eucharist, in this way identifying him with a fundamental Christian sacrament and allying the new saint with mainstream Catholicism. On the other hand, the ahistoricism, tenderness, and evanescence of this work reaffirm the values of a mystic, popular spirituality.[1]

The purpose of this sketch remains unclear, and no known drawings, paintings, or documents relate to it. The painting possibly functioned as a *modello* for an altarpiece or other religious painting that Tiepolo never executed, perhaps commissioned in the outpouring of interest caused by the saint's recent canonization. The exaggerated perspective and the use of illusionistic sculpture connect the work to one of Tiepolo's most celebrated early projects, the frescoes in the Palazzo Patricale in Udine,[2] another indication that *Saint Luigi Gonzaga in Glory* dates to the late 1720s. Its handling recalls another early sketch, *The Martyrdom of Saint Agatha* (cat. no. 6), a similar work difficult to align with a major commission of the late 1720s. Tiepolo received few altarpiece commissions early in his career, and so another possibility is that Tiepolo executed this work on speculation in order to present his skills as a major ecclesiastical painter.

An inscription on the verso, *GIO : BATTISTA : TIEPOLO 1735*, connects the painting to the family of the sculptor Andrea Fantoni (1659–1734), who worked with Tiepolo on the sculpted frame surrounding the painter's 1734 high altar of the Ognissanti in Rovetta. However, this inscription surely refers to the date he presented the sketch to the family rather than to the date of execution.[3] This work thus demonstrates how Tiepolo could sometimes use an oil sketch, first as an object retained in the studio, then as a gift to a friend and colleague, a token of the close working relationship between the two men. ❧

NOTES

1 For more on these fundamental debates, see Rosa 1999, 47–57.
2 Pedrocco 2002, 212–14.
3 Morassi 1938, 142.

4 *Apollo and Phaethon*

ca. 1731
Oil on canvas
64.1 × 47.6 cm (25¼ × 18¾ in.)
Los Angeles County Museum of Art, M.86.257

PROVENANCE

Veil-Picard collection, France, until
about 1960; private collection,
Switzerland; sold, Sotheby's, London,
December 11, 1985, lot 19, to Bob P.
Habolt and Co., New York; sold
to the Los Angeles County Museum
of Art, 1986.

EXHIBITIONS

Fort Worth 1993, no. 8.

BIBLIOGRAPHY

Conisbee, Levkoff, and Rand 1991,
161–64, fig. 42; Brown 1993, 167–68,
fig. 8; Gemin and Pedrocco 1993,
268, fig. 102b; Christiansen 1996, 292,
294n.4; *Giambattista Tiepolo* 1998, 33, 37,
112, fig. 14; Pedrocco 2002, 219–20,
fig. 71.2.b.

THE STORY OF APOLLO AND PHAETHON
is best known from Ovid's moving
interpretation from the *Metamorphoses* (1:750–
2:380). When aspersions were cast on the divine
parentage of Phaethon—son of the mortal
Clymene and the sun god, Apollo—his mother
brought the young man to Apollo's heavenly
palace to meet his father. After warmly embrac-
ing his son, Apollo granted Phaethon one wish,
and the young man impetuously asked to drive
the chariot of the sun. Apollo tried to dissuade
Phaethon from this rash request, but—incapable
of overcoming his son's steadfast insistence
and rushed by the departure of the goddess of
dawn—Apollo unwillingly assented. Apollo
instructed his son carefully, but the steep path
across the sky and the unmanageable horses
overwhelmed the young man, who quickly lost
control of the chariot and veered too close to
the zodiac. Scorpio thrashed his tail in response
to the heat, terrifying Phaethon, who dropped
the reins. The horses bolted wildly across the
skies, scorching heaven and earth, until Zeus
threw a thunderbolt to regain control of the sun,
demolishing the chariot and sending Phaethon
plunging to his death.

Artists depicting this myth were usually
attracted to the dynamism of Phaethon's fall, a
subject Tiepolo himself had painted in an early
1719–20 fresco for the Palazzo Baglioni in
Massanzago, near Padua.[1] By contrast, in the Los
Angeles composition Tiepolo presents the psy-
chologically taut moment in which Apollo vainly
attempts to dissuade his son from his imprudent
desire to drive the chariot. Father and son stand
at center, bathed in an aureole of light. Their
gestures echo one another: Apollo raises his arm
to ward off his son's entreaties while Phaethon
gestures urgently at the horses and—foreshad-
owing later events—points to Scorpio in the
zodiac behind him. Meanwhile, three horses
rear up at bottom right, barely restrained by the
winged Hours. At the top of the canvas, Saturn,
the god of time, rises, bearing his scythe in
ominous anticipation of Phaethon's impending
doom. Tiepolo paid close attention to the clas-
sical text, carefully representing such Ovidian
details as the monumental marble column of
Apollo's palace; the golden chariot, attended by
the Hours; and the personifications of the four
seasons at center right: Spring bearing a garland
of flowers, Summer with wheat and a flaming
torch, Autumn holding a crown of grape leaves,
and Winter as a bearded man huddled at rear.[2]

The sketch at the Los Angeles County
Museum of Art represents a frescoed ceiling for
the Palazzo Archinto in Milan (fig. 4.1), destroyed
by an American bombardment in August 1943.

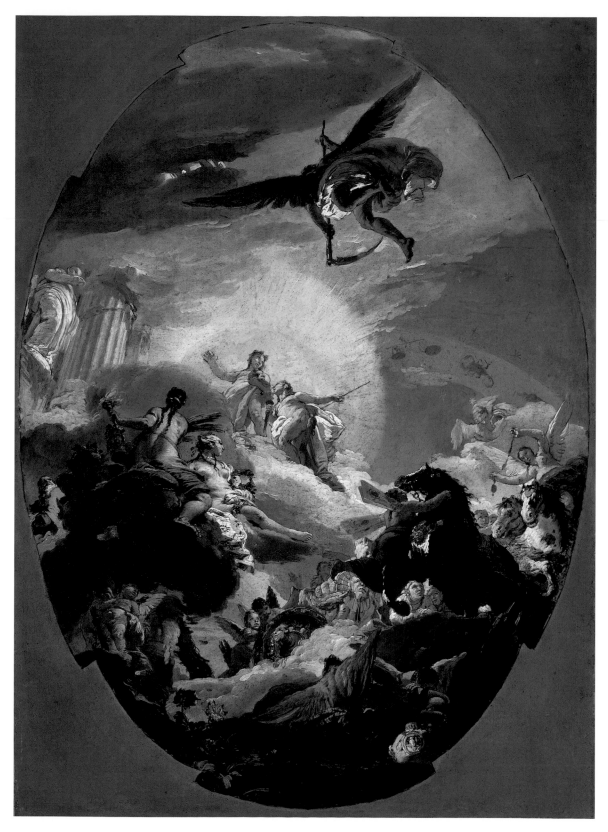

CAT. NO. 4

FIGURE 4.1 Giambattista Tiepolo. *Apollo and Phaethon*, 1731.
Fresco destroyed in World War II. Formerly Milan,
Palazzo Archinto. Photo: Scala/Art Resource, New York.

FIGURE 4.2 Giambattista Tiepolo. Oil sketch for *The Triumph of the Arts and Sciences*, ca.
1731. Oil on canvas. Lisbon, Museo Nacional de Arte Antiga. Photo: José Pessoa; Divisão de
Documentação Fotográfica, Instituto Português de Museus.

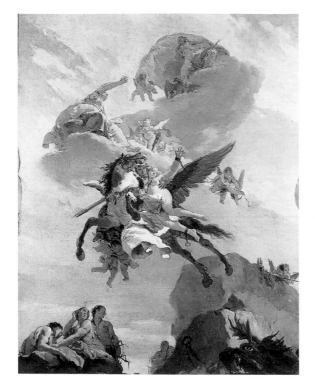

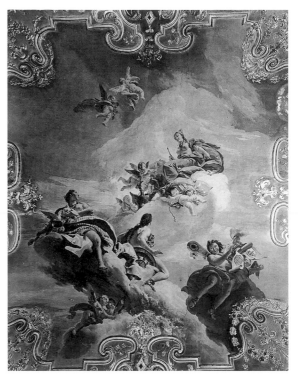

FIGURE 4.3 Giambattista Tiepolo. Oil sketch for *Perseus and Andromeda*, ca. 1730. Oil on paper mounted on canvas. New York, Frick Collection, 18.1.114.

FIGURE 4.4 Giambattista Tiepolo. *Juno Presiding over Fortune and Venus*, 1731. Fresco destroyed in World War II. Formerly Milan, Palazzo Archinto. Photo: Scala/Art Resource, New York.

Carlo Archinto, a major early *settecento* Milanese patron of science and the arts, commissioned the frescoes in 1731, probably at the instigation of Archinto's librarian, Filippo Argelati. These Milanese works were Tiepolo's first major ceiling projects outside the Veneto, at the cusp of Tiepolo's soon-to-explode international recognition.[3]

The project comprises five frescoes, probably executed in two separate campaigns. The vast *Triumph of the Arts and Sciences* (fig. 4.2) dominated the family's important library, while four smaller ceiling frescoes appeared in surrounding rooms: *Perseus and Andromeda* (fig. 4.3), *Juno Presiding over Fortune and Venus* (fig. 4.4), *Nobility*, and *Apollo and Phaethon*.[4] While the main ceiling refers primarily to the magnanimous artistic patronage of the Archinto family, the other works relate to the marriage of Filippo Archinto to Giulia Borromeo Grillo in April 1731. Some of these nuptial references are straightforward, such as, in *Juno*, the presence of Hymen, the god of marriage, holding the arms of the Archinto and

Borromeo families. Others may relate to epithalamic poetry commissioned at the time of the marriage, including *Apollo and Phaethon*, which draws on the genre's common association of the bride with the sun.[5] Tiepolo underscores this connection by the unusual inclusion of sunflowers at bottom right, surely a reference to Clytie, transformed into a sunflower to follow her beloved Apollo and thus a symbol of fidelity.[6]

Despite his devotion to Ovid, Tiepolo presents the narrative with creative invention and remarkable ease and assurance. In contrast to the early Palazzo Sandi ceiling (see cat. no. 1), in which Tiepolo separated the principal scenes around the edges of the composition, *Apollo and Phaethon* represents an enormous step forward, interweaving the subnarratives into a sophisticated spiraling composition. Imagined as a ceiling painting, the *di sotto in sù* composition radically foreshortens all the figures, accentuating the rise of Phaethon to the heavens. Sharp contrasts of light and dark create a dramatic sense of sunlight by opposing the bright rings of light

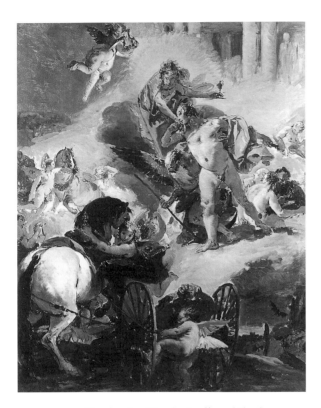

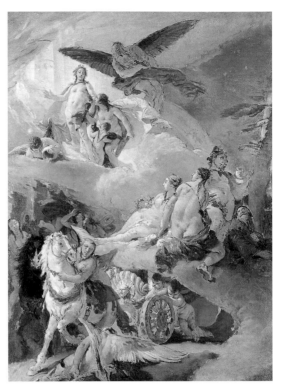

FIGURE 4.5 Giambattista Tiepolo. *Apollo and Phaethon*,
ca. 1733–36. Oil on canvas. County Durham, England, Barnard
Castle, The Bowes Museum.

FIGURE 4.6 Giambattista Tiepolo. *Apollo and Phaethon*,
ca. 1733–36, Oil on canvas. Vienna, Gemäldegalerie der
Akademie der bildenden Künste.

that surround the protagonists with the rich, dark
colors below (the double ground layer, reddish
browns and ocher, heightens this intensity of
color). The light tonalities of the painting's cen-
ter band stand apart from the sinister shadows
formed by the horses and the clouds, accentuating
the sense of foreboding.

This painting follows the finished fresco
quite closely, a feature rarely exhibited in Tiepolo's
sketches for ceiling frescoes (for example, cat.
nos. 1 and 8). For this reason most scholars have
argued against it as a preliminary design, seeing
the work as an unusually high-quality *ricordo* of
the ceiling, entirely by Tiepolo's hand.[7]

How this painting relates to the other paint-
ings and drawings of this subject from Tiepolo's

early career remains a hotly contested question.
Around the time of the Palazzo Archinto
commission Tiepolo executed a number of other
sketches on the theme of Apollo and Phaethon,
but their relationship to the LACMA canvas and
the ceiling itself remains unclear. Two beauti-
ful oil sketches from Barnard Castle and Vienna
(figs. 4.5–6) are easel paintings, with composi-
tions in a rising S-curve, free of any *di sotto in sù*
effects. The Vienna sketch, breezily painted
on an unusual blue-gray ground, depicts a slightly
later moment in the narrative, with Time taking
Phaethon away from Apollo to the awaiting
chariot. The Barnard Castle work, by contrast,
bears a much closer connection to the actual
ceiling, not only in its tonality but also in such

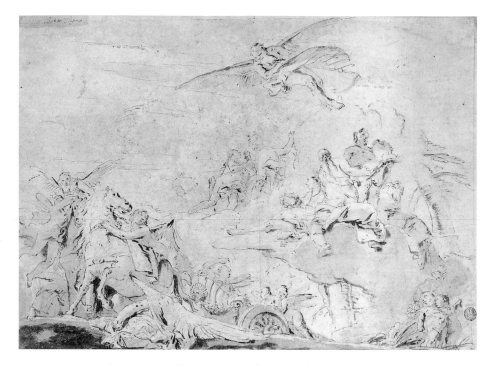

FIGURE 4.7 Giambattista Tiepolo. Study for *Apollo and Phaethon*, ca. 1730. Pen and ink with brown wash on paper. London, The British Museum, 1917-5-12-2. Presented by Henry Oppenheimer.

details as the chariot pushed by putti, the grouping of the Seasons, the zodiac crossing the auroral sky, and the position of father and son. Beverly Louise Brown considers the Vienna picture a preliminary sketch executed after Tiepolo accepted the commission but before he arrived in Milan, but other scholars disagree, considering both paintings later reworkings of the same theme, with Christiansen dating them as late as ca. 1733–36.[8] Equally puzzling is a large drawing in the British Museum (fig. 4.7) that seems to come between the Vienna picture and the Archinto ceiling. The drawing retains the position of the rearing horse and chariot from the easel painting, but it adopts the *di sotto in sù* perspective—only the earlier type that Tiepolo had used for the Palazzo Sandi ceiling, with the scene arranged along a cornice line. ❧

NOTES

1 Pedrocco 2002, 198.
2 Entry by Richard Rand in Conisbee, Levkoff, and Rand 1991, 161, 163.

3 For an interpretation of the ceilings and the overall progression of the paintings, see especially Sohm 1984; and Levey 1986, 54–61.
4 Like the other smaller ceilings, *Apollo and Phaethon* was surrounded by stuccos, which incorporated eight grisailles by Tiepolo, in this case presenting other stories from Apollo's life.
5 Sohm 1984, 71.
6 Sohm 1984, 70–71. Clytie also derives from Ovid's *Metamorphoses* (4:169–270).
7 Beverly Louise Brown (1993, 167) and Richard Rand in Conisbee, Levkoff, and Rand 1991, 163, argue convincingly for the work as a *ricordo*. Keith Christiansen provides the most significant counterargument, asserting that the uniform level of "style and character" of the LACMA sketch with the *modelli* in Lisbon and the New York makes it difficult to argue for this picture as a *ricordo* (Christiansen 1996, 295n.4). The Lisbon sketch, however, differs considerably from the final composition, and Tiepolo executed the Frick sketch on paper mounted on canvas, two important distinctions from the LACMA painting that make it difficult to see the three paintings as a unified group.
8 Antonio Morassi (1962, 3, 66) also considered the works preliminary sketches. Beverly Louise Brown (1993, 161–66) considers the Barnard Castle sketch a nineteenth-century pastiche but accepts the Vienna canvas as a preliminary sketch. For the most persuasive arguments for the paintings as later interpretations of the myth by Tiepolo, see Christiansen 1996, 292–95.

5A *Saint Rocco*

ca. 1730–35
Oil on canvas
44 × 33.5 cm (17⅜ × 13⅛ in.)
The Samuel Courtauld Trust at the Courtauld Institute Gallery,
Courtauld Institute of Art, London; inv. 171

PROVENANCE

Sold, Christie's, London, 1905, to Julius Böhler, Munich; sold to Baron von Stumm, Rauisch-Holzhausen, Hessen, Germany, 1906; Count Zoubow, Paris; sold to Count Antoine Seilern (1901–1978), London, 1952; by bequest to the Home House Trustees for the Courtauld Institute of Art, University of London, 1978.

EXHIBITIONS

London 1960, no. 445.

BIBLIOGRAPHY

Sack 1910, 99, 191; Morassi 1950, 209; Seilern 1959, 160, pl. CXXXIV; Morassi 1962, 20, fig. 163; Piovene and Pallucchini 1968, 96–97, fig. 77h; Seilern 1971a, 57; Braham 1981, 73–74, fig. 108; Bradford and Braham 1989, 25; Gemin and Pedrocco 1993, 306, 308–9, fig. 193; Pedrocco 2002, 230–31, fig. 103.9.

5B *Saint Rocco*

ca. 1730–35
Oil on canvas
43 × 32 cm (16 9/16 × 12 5/8 in.)
San Marino, California, The Huntington Library,
Art Collections, and Botanical Gardens

PROVENANCE

Probably James Smith Inglis (1852–1907), New York; upon his death probably held in trust by Cottier and Co., New York; sold, Cottier and Co. sale, American Art Gallery, New York, March 11, 1909, lot 78, to Henry E. Huntington, San Marino, California.

EXHIBITIONS

None.

BIBLIOGRAPHY

Morassi 1950, 202–3, 206, fig. 9; Morassi 1962, 47, fig. 157; Piovene and Pallucchini 1968, 96–97, fig. 77n; Gemin and Pedrocco 1993, 306, 310, fig. 200; Pedrocco 2002, 230–31, fig. 103.16.

SAINT ROCCO (CA. 1295–1327; ALSO CALLED Saint Roch) relinquished his family fortune, traveled from Montpellier, France, to Italy in the disguise of a pilgrim, and dedicated himself to curing the plague-stricken. Contracting the disease himself near Piacenza, Rocco withdrew to the outlying forest, where a dog provided him with bread from a nearby bakery and healed his wounds by licking them. After recovering he returned to France, where he was—according to some versions of his life—mistaken as a spy and thrown into prison unrecognized, and died. Pilgrims and those suffering from the plague commonly invoked Rocco, and many altars,

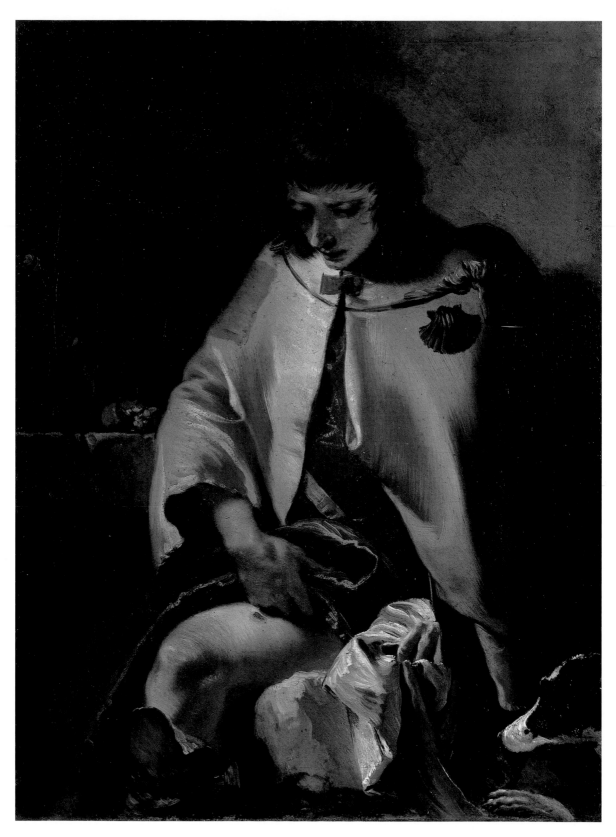

CAT. NO. 5A

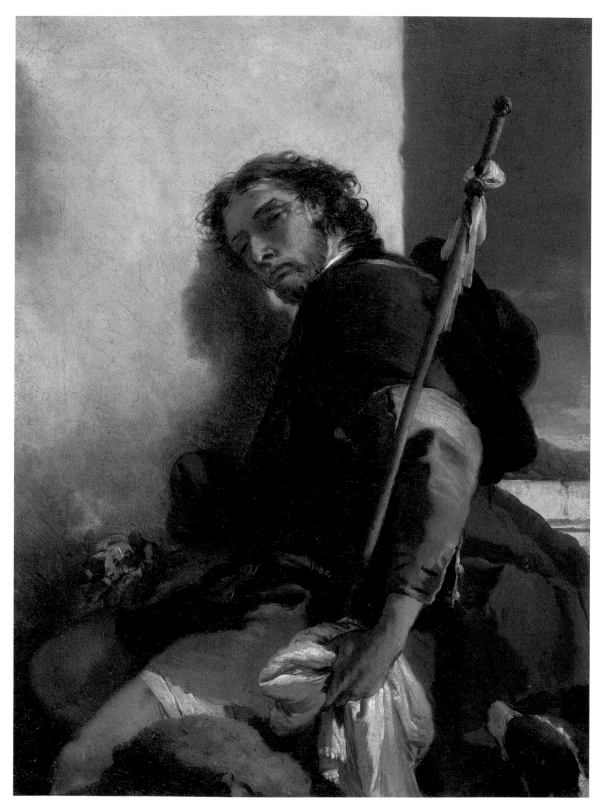

CAT. NO. 5B

FIGURE 5.1 Giambattista Tiepolo. *Saint Rocco*, 1730–35. Oil on paper mounted on canvas. Philadelphia Museum of Art, John G. Johnson Collection.

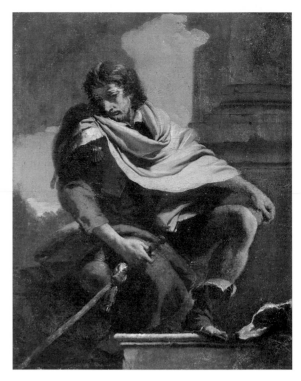

FIGURE 5.2 Giambattista Tiepolo. *Saint Rocco*, 1730–35. Oil on canvas. Sydney, Art Gallery of New South Wales, gift of Sir J. S. Heron 1912, 1152. Photo: Ray Woodbury for AGNSW.

churches, and confraternities were dedicated to the saint throughout Europe.

In the Courtauld canvas, a beardless Saint Rocco, with downturned head and closed eyes, sits facing the viewer. Tiepolo pulls the young man to the front of the picture plane; the simple gray wall, stone ledge, and dark shadows accentuate the saint's monumental profile. Despite his patched cloak, unkempt hair, and shabby boot, Saint Rocco bears clear traces of his cast-off wealth. Tiepolo paints his garments with radiant luxuriousness: a brightly lit apricot mantle covers a long, shimmering, vermilion robe. The walking stick, loaf of bread, and scalloped shell pinned to his cloak all indicate he is a pilgrim, but the saint rests from his peregrinations, pulling back his robe to reveal a plague sore, highlighted with transparent red glaze, tenderly observed by the dog, whose head and paw poke into the image at bottom right.

By contrast, the Huntington's *Saint Rocco* depicts an urban outcast instead of a pilgrim, slumped before a stuccoed wall, a distant landscape visible through the window at right. Exhausted and haggard, Rocco—now bearded, modestly clad, and significantly older—rests his head and shoulder against the wall, barely able to open his eyes, prop up his staff, and clasp a piece of bread. Here Tiepolo reverses the relationship of light and dark, brightly lighting the composition from the right and shrouding the saint's face and torso in darkness. The striking shadow formed on the wall increases his distance from the viewer, locking the saint into his enervated position.

In 1950, Antonio Morassi first identified a unified group of images by Tiepolo, all of similar scale, depicting the same model in various guises as Saint Rocco (figs. 5.1–2).[1] Subsequent authors expanded this group of paintings, with Filippo Pedrocco recently counting twenty-one as autograph.[2] All scholars agree that the works connect to the Confraternità di San Rocco in Venice. The church of San Rocco was long the site of exhibitions in the city,[3] and Tiepolo himself had a lengthy relationship with the

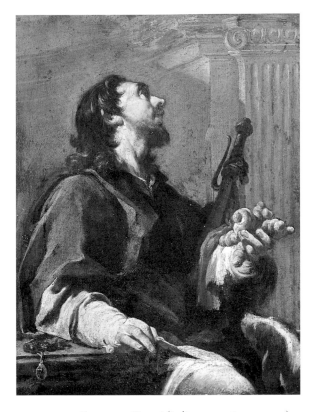

FIGURE 5.3 Francesco Pittoni (Italian, ca. 1654–ca. 1735). *Saint Rocco*, 1727. Oil on canvas. Budapest, Szépmüvészeti Múzeum.

church, the site of the painter's first exhibition, in 1716. Moreover, his mother was in close contact with two key confraternity leaders, and one of these men, Anton Francesco Giusti, is the only person in Tiepolo's lifetime documented as owning a painting from this series.[4] Tiepolo was not the first artist to paint multiple versions of the confraternity's titular saint. Giambattista Pittoni (fig. 5.3), Giovanni Battista Piazzetta, Sebastiano Ricci, and Gaspare Diziani all painted similarly scaled versions of Saint Rocco in the same period, presumably for members of the sodality. The decidedly urban setting of most of these representations (relatively unusual in depictions of the saint) accentuates the connection of the images to the urban mission of the organization.

Tiepolo brought astonishing variety to this series, presenting the saint as ecstatic, contemplative, despondent, learned, and even confrontational, all within the same limited format. The works combine genre painting and devotional imagery, and in their ability to present ceaseless variations on a single theme, they connect to similar series executed by Tiepolo throughout his life, including the Flight into Egypt variations that span his career, the Capricci prints of the early 1740s, and the Scherzi di Fantasia of about 1743–57. These last two series are customarily described as *capricci*, a term applied to the inventiveness of musical variation, and the Saint Rocco group should be considered a sober relation to these works.[5] ❧

NOTES

1 Morassi 1950, 202.

2 Pedrocco 2002, 230–31.

3 For the San Rocco exhibitions, see, for example, Francis Haskell and Michael Levey, "Art Exhibitions in Eighteenth-Century Venice," *Arte veneta* 12 (1958): 181–83, 185.

4 Federico Montecuccoli degli Erri, "Giambattista Tiepolo: Nuove pagine di vita privata," in Puppi 1998, 1:71.

5 For an intelligent review of these works, including the terms *capriccio, fantasia,* and *scherzo,* see Christiansen 1996, 338–69.

6 *The Martyrdom of Saint Agatha*

1734
Oil on canvas
48 × 29.1 cm (18⅞ × 11½ in.)
The Samuel Courtauld Trust at the Courtauld Institute Gallery,
Courtauld Institute of Art, London; inv. 396

PROVENANCE

Private collection, Vienna, by 1937;
Broglio collection, Paris, after 1945;
Agnew's, London; sold to Count
Antoine Seilern (1901–1978), London,
1969; by bequest to the Home House
Trustees for the Courtauld Institute of
Art, University of London, 1978.

EXHIBITIONS

Vienna 1937, no. 125.

BIBLIOGRAPHY

Morassi 1962, 40, fig. 125; Piovene and
Pallucchini 1968, 101; Seilern 1971b,
20–21, pl. VI; Braham 1981, 75, fig. 110;
Bradford and Braham 1989, 5; Farr,
Bradford, and Braham 1990, 68, 72

(illus.); Gemin and Pedrocco 1993, 316,
fig. 215a (as formerly Broglio collection,
Paris); *Giambattista Tiepolo* 1998,
126n.2; Pedrocco 2002, 238, fig. 125.a
(as formerly Broglio collection, Paris).

A THIRD-CENTURY SICILIAN MARTYR, Agatha attracted the attention of a local Roman official through her beauty, wealth, noble status, and open practice of Christianity. Seeking to humiliate the young woman and cause her to repudiate Christianity, the official sent Agatha to live in a brothel. Undaunted, she refused to worship idols and was subjected to torture on the rack; following that, her breasts were twisted and ultimately severed. Thrown into prison and denied medical attention, Agatha was visited at night by Saint Peter, who miraculously healed her wounds. Steadfast in her faith, she was tortured yet again and ultimately died in prison.

Tiepolo concentrated on Agatha's best-known and most shocking torture, the vicious severing of her breasts. Raised on a masonry platform and irradiated in bright light, Agatha throws out her arms and appeals to heaven after her appalling torment. An older man rushes to her aid, applying a light yellow cloth to stem the bleeding, while another figure moves in behind her, bearing the platter on which her severed breasts would later be displayed. Meanwhile, a brutish, muscular executioner returns his sword to its scabbard, scowling at his victim. Three exotically attired men at right impassively observe the scene, with classical architecture gleaming in the background, while a mourning woman and child slump down in the foreground, unable to behold the horror before them.

This painting is likely an early sketch for an altarpiece for the Buzzaccarini Chapel in the Basilica of Sant'Antonio, Padua (fig. 6.1).[1] A second sketch (fig. 6.2), last recorded in the Broglio collection, reveals the progression from the initial spontaneous, active concept presented in the Courtauld canvas to the restraint of the final version.[2] Abandoning the curving arc of figures spilling outward into the viewer's space and the pinwheel of attending figures, Tiepolo moved toward a much more simplified, planar composition. He gradually pulled the figures of Agatha and her attendants down closer to the beholder, closing off the composition at left with an attending page. The saint now kneels in supplication; the swordsman leans in rather than out; and Saint Peter, hovering above, mercifully receives Agatha's plea. The revisions demonstrate the process Tiepolo typically followed as he developed his formal, public compositions, lowering the spontaneity and emotional pitch of his oil sketches and drawings in favor of the more formal expression and conventionalized rhetoric of the finished work.[3]

The ambiguous space marked out by the diagonal beam at the top of the sketch and the

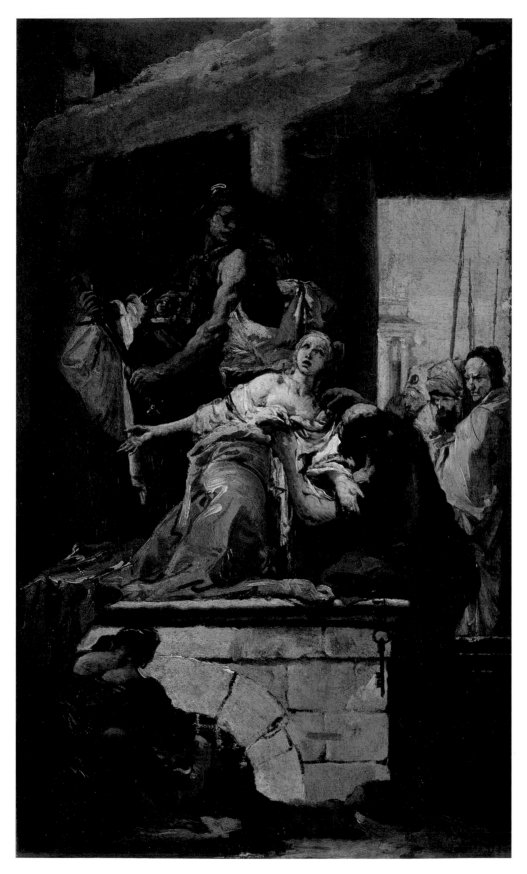

CAT. NO. 6

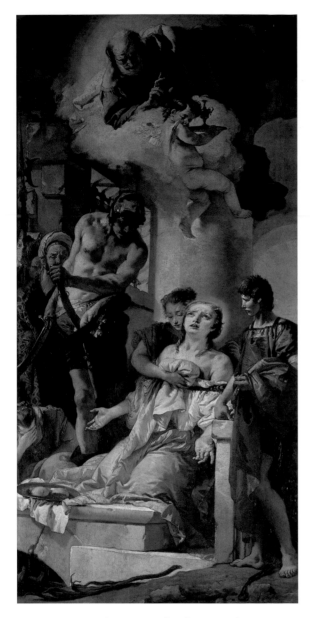

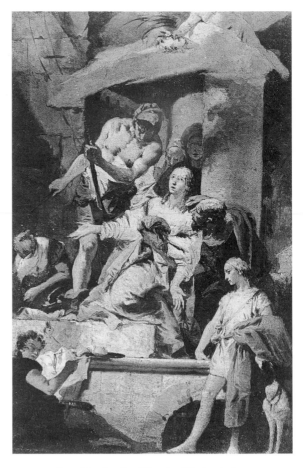

FIGURE 6.2 Giambattista Tiepolo. Oil sketch for
The Martyrdom of Saint Agatha, ca. 1734. Oil on canvas. Present
location unknown. Dipartimento di Storia delle Arti e
Conservazione dei Beni Artistici "G. Mazzariol," Università
Ca' Foscari di Venezia, Fototeca A. Morassi, unità 177.

FIGURE 6.1 Giambattista Tiepolo. *The Martyrdom
of Saint Agatha*, 1734–37. Oil on canvas. Padua, Basilica of
Sant'Antonio.

inconsistent anatomy of the figures reveal that
Tiepolo concentrated on building this composi-
tion chiefly through color relationships. Although
this painting is the most seriously damaged
of all the Courtauld oil sketches—the left side
of the canvas has been abraded, and there
are many losses to the upper layers of the bald
attendant's red-brown robes and the mourners
at bottom—it still presents an immensely
sophisticated palette. A complex balance of reds,
oranges, and yellows dominates the center of

the composition, in contrast to the pale, drained
flesh of the martyr. The red splashes of Agatha's
blood mix with passages of rust, pink, and tomato
(as well as the reddish ground), while layered
zigzags of paint, drawn in wet with a brush, con-
vey the agitation of the drapery.

Tiepolo returned to the subject in the mid-
1750s for an altarpiece, now in the Gemälde-
galerie, Berlin, commissioned by the Benedictine
nuns at Sant'Agata, Lendinara, near Rovigo
(fig. 6.3). The prominent play of halberds and

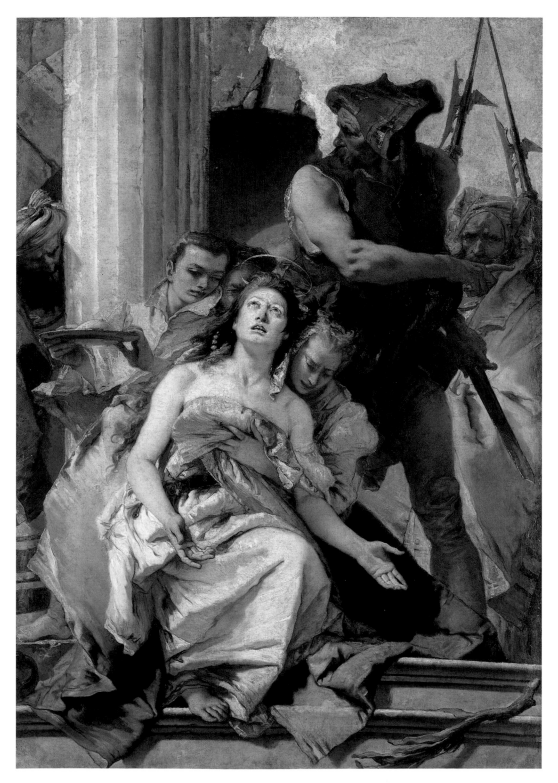

FIGURE 6.3 Giambattista Tiepolo. *The Martyrdom of Saint Agatha*, ca. 1755. Oil on canvas. Berlin, Staatliche Museen zu Berlin, Gemäldegalerie. Photo: Jörg P. Anders, Berlin.

FIGURE 6.4 Giambattista Tiepolo. *Head of a Man Looking Up*, ca. 1755. Red and white chalk on blue paper. Los Angeles, J. Paul Getty Museum, 2002.31.

Agatha's raised knee—features of the original oil sketch, abandoned in the Padua altarpiece— suggest that Tiepolo retained the sketch and consulted this composition before embarking on the second version twenty years later. The intense facial expression, worked out coloristically in the Courtauld sketch, is also documented in a series of drawings, including two in Berlin[4] and one at the Getty (fig. 6.4). ❧

NOTES

1 Based on documents indicating that a delegation from Padua went to Venice to sign the contract for the altarpiece with Tiepolo in 1734, Antoine Seilern (1971b, 20–21) hypothesized that the artist must have presented the sketch to his patrons at that time.

2 Rodolfo Pallucchini (Piovene and Pallucchini 1968, 101) considered the second sketch a copy after the final composition, but it differs considerably from the altarpiece and surely records an intermediate stage, even if it is a studio work. Antoine Seilern (1971b, 20–21) noted that the motifs of the stone platform, the executioner, and the halberds also appear in a number of related works by Tiepolo from the same period, including the 1733 *Beheading of Saint John the Baptist* in the Colleoni Chapel in Bergamo and a drawing of *The Martyrdom of Saints Domnius, Eusebia, and Domninus* in the Metropolitan Museum of Art (to which I would add the Metropolitan's *Martyrdom of Saints Gervase and Protase*), suggesting that a variety of drawings and *modelli* were circulating around the studio in this period.

3 On this point, see especially Christiansen 1999.

4 Knox 1980, 1:212–14.

ca. 1734
Oil on canvas
58.5 × 32.5 cm (23 × 12¾ in.)
The Samuel Courtauld Trust at the Courtauld Institute Gallery,
Courtauld Institute of Art, London; inv. 395

PROVENANCE

Possibly Cheremetiev (Cheremetjew) collection, Russia; Nicholson, London, 1935–39; John Bass, New York; sold, Parke-Bernet Galleries, New York, January 25, 1945, lot 3 (as *Sketch for an Altar Painting*); sold, Sotheby's, London, June 24, 1970, lot 34, to Colnaghi, London; sold to Count Antoine Seilern (1901–1978), London, 1970; by bequest to the Home House Trustees for the Courtauld Institute of Art, University of London, 1978.

EXHIBITIONS

None.

BIBLIOGRAPHY

Morassi 1957, 176–77, 177n.6 (as *Giovanni Nepomuceno e la SS. Trinità*); Morassi 1962, 19, fig. 128 (as *The Holy Trinity with the Martyrdom of Saint John Nepomuk*); Piovene and Pallucchini 1968, 100, fig. 101 (as *La Trinità e il martirio di San Giovanni Nepomuceno*); Levey 1971, 224–25, no. 8; Seilern 1971b, 18–19, pl. V; Heine 1974, 148–49, fig. 2; Levey 1980, 211, 249; Braham 1981, 74, fig. 109; Levey 1986, 76; Bradford and Braham 1989, 25; Gemin and Pedrocco 1993, 324–25, fig. 226; Levey 1994, 225; Whistler 1995, 626; Pedrocco 2002, 242, fig. 133.

SAINT CLEMENT, GENERALLY ACCEPTED as the third pope to follow Saint Peter, was banished to the Crimea by the emperor Trajan. Clement initiated an immense missionary effort there, resulting in a church-building campaign and massive conversions at the fringes of the Roman Empire. To stem this success, Trajan ordered Clement tossed into the sea, bound to an anchor.

Tiepolo presents the saint in the moment before his martyrdom. An oarsman prepares the boat—an enormous iron anchor ominously protrudes into the sky at left—with the Black Sea visible in the lower corner. Clad in full papal regalia with his miter and crosier on the ground before him, Clement has thrown himself to his knees as he experiences an overwhelming vision of the Trinity, suspended on an enormous blue-gray cloud that descends to the crowd below. Flanked on the left by two angels gracefully supporting an enormous cross, God the Father presides, leaning forward and spreading his arms in blessing. Christ, by contrast, reclines on a globe, gazing tenderly down at the pope, while the Holy Spirit, in a naturalistic touch characteristic of Tiepolo, vigorously flaps its wings to slow its descent. Although a woman has collapsed onto the ground before the boat in despair, seven men and a spotted hound gaze coolly upon the praying pope. These exotically clad figures—with long beards, turbans, and fur hats—signify the Russian setting rather than the Trajanic Empire, and they mark an early appearance of the theatrical chorus of extras Tiepolo often employed, not so much for narrative purposes but for thoughtful and dramatic contrast to the protagonist's mood.[1]

This painting is probably an early sketch for a major altarpiece commissioned by Clement Augustus, archbishop elector of Cologne (r. 1723–61), for the high altar of Notre-Dame-Kirche, an Augustinian church at Schloss Nymphenberg (fig. 7.1). (This altarpiece is also known through its spectacular presentation sketch in the National Gallery, London [fig. 7.2].)[2] While no specific documents connected to the Schloss Nymphenberg painting have yet emerged, it is known that Clement August traveled to Venice three times, and he commissioned work extensively from Venetian painters (although no record of contact with Tiepolo survives). The scalloped top of the Courtauld sketch further underscores its connection to the German altarpiece, for this shape reflects that

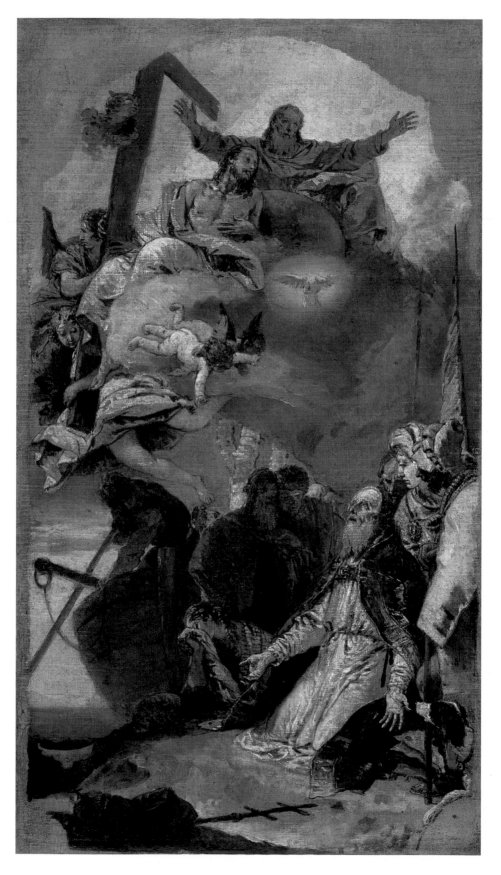

CAT. NO. 7

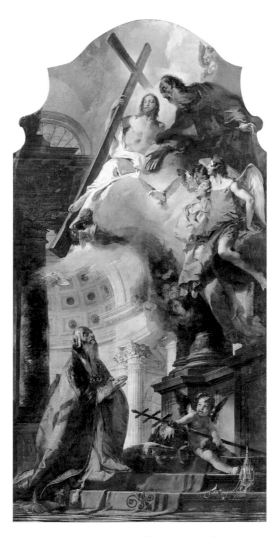

FIGURE 7.1 Giambattista Tiepolo. *Saint Clement Adoring the Holy Trinity*, ca. 1734–39. Oil on canvas. Loan of the Staatliche Schlösserverwaltung to the Bayerische Staatsgemäldesammlungen, Munich; inv. no. L 877.

of the final painting and indicates that Tiepolo had information transmitted to him regarding the intended scale and the framing of the work.

The altarpiece represents a radical revision of the initial sketch. Instead of presenting Clement at the moment of his martyrdom, Tiepolo eliminated any sense of historical narrative in the final painting, reducing the subject of the composition to Clement kneeling in papal regalia within a grand ecclesiastical interior before a majestic vision of the Trinity.

Saint Clement, a shadowy first-century figure, enjoyed an explosion of interest in the early eighteenth century. Pope Clement XI

Albani (r. 1700–1721) adopted the saint as his namesake and promoted scholarship on this early Christian figure.[3] Saint Clement became the subject of lively interpretations by early *settecento* Roman artists, especially the series of paintings for the Roman basilica of San Clemente. These works concentrated on narrative detail; Tiepolo, on the other hand, chose to follow the format of his other early religious paintings by placing the saint in a highly charged visionary moment (e.g., cat. no. 3). Clement Augustus identified closely with this early Christian saint, and besides the altarpiece by Tiepolo, he commissioned numerous churches and other altarpieces

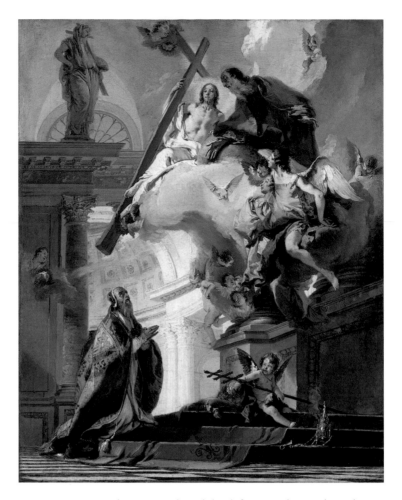

FIGURE 7.2 Giambattista Tiepolo. Oil sketch for *Saint Clement Adoring the Holy Trinity*, ca. 1734–39. Oil on canvas. London, National Gallery. © National Gallery, London.

in honor of his namesake, such as *The Martyrdom of Saint Clement* by Tiepolo's Venetian contemporary Giambattista Pittoni for the Clemenskirche in Münster.[4]

Notre-Dame-Kirche was an Augustinian church, and the Trinitarian subject of Tiepolo's painting was a cornerstone of Augustinian theology.[5] Thus, one possible reason for the rejection of the Courtauld sketch may have been that the church wanted an altarpiece focused exclusively on the Trinity, and a representation of Clement's imminent martyrdom may have been seen as a distraction from that theme.

A second version of the Courtauld composition appears in the Galleria dell'Accademia Carrara in Bergamo. It is probably a studio copy made as a *ricordo* for the artist when the original was sent to Germany for approval.[6] ❧

NOTES

1 Christiansen 1999, 687–88.
2 Michael Levey (1971) first correctly identified the subject and connected the Courtauld sketch to the paintings in Berlin and London, while Barbara Heine (1974) clarified the details of the commission and the meaning of the picture within the archbishop's larger pattern of patronage.
3 Christopher M. S. Johns, *Papal Art and Cultural Politics: Rome in the Age of Clement XI* (Cambridge: Cambridge University Press, 1993), especially 103–4.
4 The altarpiece was destroyed in World War II but an oil sketch survives in Uppsala, Sweden. See Franza Zava Roccazzi, *Pittoni* (Venice: Alfieri, 1971).
5 For more on the Augustinian aspect of the church, see Heine 1974, especially 150–51.
6 Whistler 1995, 626; Pedrocco 2002, 325, fig. 227.

1743
Oil on canvas
123 × 77 cm (48⅜ × 30⅜ in.)
Los Angeles, J. Paul Getty Museum, 94.PA.20

PROVENANCE

Probably retained by Giambattista Tiepolo in his studio; upon his death, probably by inheritance to his son, Giandomenico Tiepolo; Edward Cheney (d. 1884), London and Badger Hall, Shropshire, England; upon his death, held in trust by the estate of Edward Cheney; sold, Christie's, London, April 29, 1885, lot 160, to Archibald Philip Primrose, fifth earl of Rosebery (1847–1929); by inheritance to Albert Edward Harry Mayer Archibald Primrose, sixth earl of Rosebery (1882–1974), Dalmeney House, Lothian, Scotland; by inheritance to his wife, Eva Isabel Marian Strutt, countess of Rosebery (1892–1987), Dalmeney House, Lothian, Scotland; sold, Sotheby's, London, December 11, 1974, lot 15, to the British Rail Pension Trustee Company, Ltd., London; sold through Hazlitt, Gooden and Fox Ltd., London, to the J. Paul Getty Museum, 1994.

EXHIBITIONS

London and Birmingham 1951, no. 120; Venice 1951, no. 51; London 1954–55, no. 504; London 1984, no. 31; Fort Worth 1993, no. 29; Venice and New York 1996, no. 40b.

BIBLIOGRAPHY

Lorenzetti 1951, 65–67, no. 51; Watson 1952, 44; Mras 1956, 40–44; Crivellato 1960, 43; Pallucchini 1960, 88; Wescher 1960, 49; Crivellato 1962, 53; Morassi 1962, 19, 54, 57; Watson 1963, 244; Rossacher 1965, 166; Knox 1968, 397; Piovene and Pallucchini 1968, 108–9, fig. 151a.1; Rossacher 1968, 112; Zampetti 1969, 378–79, fig. 175; Rizzi 1971, 1:93; Sotheby's 1975, 1 (illus.); Barcham 1979, 430, 433, 438–40, fig. 14; Levey 1986, 112–14, fig. 108; Barcham 1989, 137; Brunel 1991, 172–73; Scirè Nepi 1991, 247; Barcham 1992, 88, fig. 22; Brown 1993, 228–31, cat. no. 29; Gemin and Pedrocco 1993, 379, fig. 346b; Alpers and Baxandall 1994, 64, 68, 151, fig. 76; Fredericksen 1995, no. 15 (illus.); Christiansen 1996, 295, 298, 300–301; Pavanello 1996, 21, 69, no. 24, 16 (illus.); Jaffé 1997, 125 (illus.); Pedrocco 2002, 267–68, fig. 186.1.b.

THE TRANSLATION OF THE HOLY HOUSE of Loreto depicts the legendary transport (or translation) by angels of the Virgin Mary's home—and thus the place where Christ was conceived—from Nazareth to Europe. According to legend, the Santa Casa first landed in Slovenia in 1291, then traveled to a number of other sites in the eastern Marches in order to find the most sacred ground before landing in Loreto in 1294. While its medieval history remains shadowy, by the fifteenth century the Holy House of Loreto had become a major European pilgrimage site, which it remains to this day.

The Getty painting is a preliminary sketch for the ceiling of the Venetian church of Santa Maria di Nazareth (also known as Santa Maria degli Scalzi) (fig. 8.1). The choice of subject was not at all unexpected for the order of Discalced Carmelites, given that their church was dedicated to the Madonna of the House of Loreto. The Carmelites enjoyed a special relationship to the Santa Casa, having been granted control over the site in 1489. The order traced its genesis to the prophets Elias and Eliseus, and they considered Mount Carmel in Palestine their point of origin. They claimed to have protected the house even before its move to Europe in 1291; the order had thus been firmly affiliated with the cult for centuries.

The city of Venice itself maintained a special devotion to the Santa Casa, as well as political and economic ties to the Marchigian town.[1] The Discalced Carmelites established themselves in Venice in 1646, dedicated their church on the feast day for the Holy House in 1650, and had a spectacular edifice, designed by Baldassare Longhena, built between 1649 and 1659.[2] In the second quarter of the eighteenth century, interest

CAT. NO. 8

FIGURE 8.1 Giambattista Tiepolo and Girolamo Mingozzi Colonna (Italian, ca. 1688–ca. 1766). *The Translation of the Holy House of Loreto*, 1745. Fresco destroyed in World War I. Formerly Venice, Santa Maria di Nazareth (Santa Maria degli Scalzi). Photo: Alinari/Art Resource, New York.

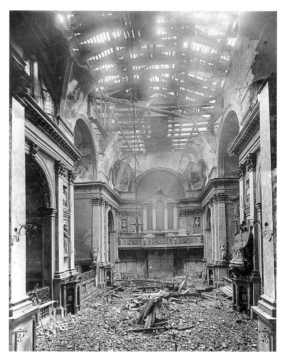

FIGURE 8.2 Santa Maria di Nazareth (Santa Maria degli Scalzi), Venice, after the bombing in 1915. Photo: Archivio Naya-Bohm, Venice.

in the Santa Casa increased considerably. Pope Benedict XIII Orsini (r. 1723–30) extended the office and mass for the cult to Venice, and an important compendium of documents, as well as an archaeological study reaffirming the Holy House's biblical origins, appeared in the 1730s. Pope Benedict XIV Lambertini (r. 1740–58) focused yet more attention on the Santa Casa, writing a treatise on Loreto. In 1744, a local Venetian parish church even sponsored the construction of a replica of the house.[3]

Tiepolo would have been the obvious choice for the Carmelites' commission. The artist enjoyed great favor from Carmelite patrons in Venice, including a major recent commission from the Scuola Grande dei Carmini in 1740.

Moreover, Tiepolo had worked in Santa Maria di Nazareth earlier in his career, frescoing two chapels in the church between 1727 and 1733, including an illusionistic ceiling depicting the founder of the Discalced Carmelites, *The Apotheosis of Saint Teresa of Ávila*.[4]

The detailed documents regarding the ceiling indicate that Tiepolo received the commission in September 1743. Although Tiepolo was the lead designer for the project, he worked with his longtime collaborator, Girolamo Mingozzi Colonna, who created a fictive architectural setting for the fresco. By the end of the year Mingozzi Colonna had asked to have the ceiling restructured, and he only finished his share of the work in April 1745, after which Tiepolo

completed the fresco in eight months.[5] Their work presents a fictive cornice, with a balustrade above, surrounding a huge opening into the sky, through which the Miracle of the Holy House appears. On the pendentives and the lower section of the vaulting, Tiepolo and Mingozzi Colonna painted scenes referring to the Ark of the Covenant, an Old Testament precursor to the Translation of the Holy House.[6]

In October 1915, the Austrian army bombed the church, destroying the ceiling (fig. 8.2), so the two preliminary oil sketches are now all that remains (cat. no. 8 and fig. 8.3). The existence of two different sketches for the same commission is unusual in Tiepolo's practice and indicates the commission's theological and compositional complexity. From the beginning, Tiepolo envisioned the central scene as entirely open to the sky. To convey the ascent and flight of the house, and to connect the heavens, the cottage in flight, and the expelled figures, Tiepolo radically foreshortened the figures and presented them all *di sotto in sù* (daringly rendering the angels far larger than the Virgin and Child). The work in Venice, the earlier of the two sketches, contains the basic elements of the later versions but positions the house in the lower register, with an energetic tilt that gives the impression of rapid movement, an effect enhanced by the figures moving across the edges of the oval composition.

The oval shape of the sketches proves that they were made before Mingozzi Colonna invented the more complex architectural form seen in the finished fresco. This change dates the sketches securely to 1743 and underlines the close working relationship between the two painters; the trumpeting angels at right, for example, reveal the artists' interest in downplaying the unalterable side vaults that encroach on the otherwise smooth expanse of the main ceiling.[7]

In the Getty sketch, the Virgin and Child stand atop the humble structure, accompanied by Saint Joseph, who kneels on a cloud to the right, his staff discarded and hands raised above his head in prayer. A swarm of angels and putti, swathed in rich daubs of color, raise the house to a distant heaven, while a group of angels enters at far right with a blast of

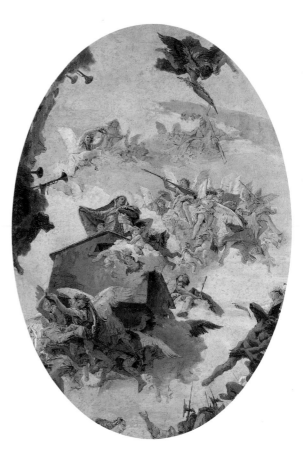

FIGURE 8.3 Giambattista Tiepolo. Oil sketch for *The Translation of the Holy House of Loreto*, 1743. Oil on canvas. Venice, Galleria dell'Accademia. Photo: Scala/Art Resource, New York.

trumpets. At top, executed in near-grisaille, a concert of angels accompanies God the Father, who opens his arms to greet the Santa Casa. In contrast to the general upsurge, a mass of dark, flailing figures in the lower register hurtles downward into the viewer's space, while a throng of turbaned men with halberds peers in from the periphery.

Unlike in the earlier sketch in the Accademia, Tiepolo shifted the Santa Casa higher, thereby centralizing and stabilizing the primary group. To increase the grandeur and monumentality of the Holy House, Tiepolo divided the complex composition into three distinct zones. The fallen angels and heretics at the bottom of the canvas now take on more force, and the heavenly figures at the top mass in a more focused pyramid. To stress the upward motion of the house, Tiepolo reduced the number of figures in the upper register gazing in from the edges.

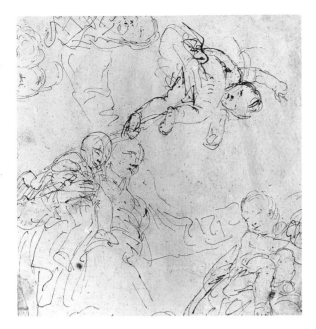

FIGURE 8.4 Giambattista Tiepolo. *The Virgin and Child (Study for "The Translation of the Holy House of Loreto")*. 1743. Pen and ink on paper. Princeton University Art Museum. Bequest of Dan Fellow Platt, Class of 1895 (1948-882).

In addition to these important compositional alterations, the two sketches reveal important doctrinal shifts, suggesting the active role of the Discalced Carmelites in creating the iconographic program. The *modello* in Venice depicts the Virgin standing on the house alone, while Christ appears in the heavens along with God the Father and the Holy Spirit, and an angel descends at upper left, bearing a lily. By contrast, in the Getty sketch, Christ appears as an infant in his mother's arms rather than as part of the Trinity. This change not only follows traditional Loretan iconography but also moves the work away from Trinitarian themes to stress Mary's role as Christ's mother and to present the Santa Casa as the home of Christ as well as the Virgin.[8] Two preliminary drawings of the Virgin (fig. 8.4), now at Princeton, record discarded possibilities and testify to the importance placed on this part of the picture.[9] The Getty sketch also highlights Saint Joseph in more saturated colors to draw more attention to his figure — appropriately, given that Saint Joseph played a crucial role in Discalced Carmelite devotion.

In the fresco, Tiepolo expanded the space among the various clusters of figures and adjusted the figure of the Virgin once again, so that she and the Christ child both look down at the worshiper, accentuating their roles as intercessors. A second crucial change came with the silvery moon that forms an enormous halo behind the Holy House. This nocturnal shift follows the legend more accurately (the Translation took place at night) and links the Madonna of Loreto to the iconography of the Immaculate Conception, a still-controversial doctrine associated with Loreto and defended with particular vigor by the Discalced Carmelites in the eighteenth century.[10]

Given the exceptionally large scale of the Getty sketch, Tiepolo executed the painting with remarkable verve and freedom. It is one of the most loosely and confidently handled of all the oil sketches in this exhibition. Particularly astonishing is the loose relation of line and color, with lines of brown paint drawn over broad swaths of color in order to articulate the forms, a technique that recalls Tiepolo's ink and wash sketches. The ground shows through everywhere, and the mark at the far left, clearly made by the end of a paintbrush striking the surface of the wet paint, speaks to the dash and bravado with which the artist executed this presentation *modello*. ❧

NOTES

1 Barcham 1979, 436.
2 For the architecture of Santa Maria degli Scalzi, see especially Douglas Lewis, *The Late Baroque Churches of Venice* (New York: Garland, 1979).
3 Barcham 1979, 436–38.
4 See Pedrocco 2002, 203.
5 For the documents surrounding this commission, see especially Fogolari 1931.
6 Knox 1968, 394–95, 397. For images of the pendentives, see Pedrocco 2002, 267–69.
7 Christiansen 1996, 300–301.
8 For traditional Loretan iconography and discourse, see Barcham 1979, 433–34; and Floriano Grimaldi and Katy Sordi, eds., *L'iconografia della vergine di Loreto nell'arte*, exhibition catalogue (Loreto: Cassa di risparmio di Loreto, 1995).
9 Mras 1956, 42–43.
10 Barcham 1979, 445–46; for more on the Immaculate Conception, see cat. no. 10 in the present volume.

Tiepolo and the Oil Sketches
for the Church of San Pascual Baylon, Aranjuez

At the very end of his career Tiepolo embarked on an unprecedented commission: seven large altarpieces for San Pascual Baylon, a new church constructed at the behest of King Charles III (r. 1759–88) for the Alcantarine friars of Aranjuez. ❧ In the nineteenth century the altarpieces were dispersed. ❧ Many were cut up or destroyed, and for this reason the five sketches of 1767 (cat. nos. 9–13A) best reveal Tiepolo's intentions for this commission. ❧ Moreover, the fine state of preservation, radiant beauty, and inventive approach to the subject matter of these paintings reveal Tiepolo's continued vitality as an important religious painter during his final years. ❧ The Aranjuez sketches from the Courtauld stand among the artist's signal accomplishments and remain a highlight of the Spanish phase of his career.

San Pascual Baylon was the first religious foundation initiated by the king, and its development was accorded the most careful attention. The church itself—the first major building project of Charles III—was designed by a Roman-trained Neapolitan architect working in Spain, Marcelo Fontón. In line with the king's taste in religious art, Fontón followed a restrained Roman baroque model for the interior (fig. G) and the facade (fig. H). Despite the riches bestowed upon the project, the church housed a community of friars known for their rigorous austerity, the Alcantarines. Founded by Saint Peter of Alcántara (1499–1562) in the mid-sixteenth century, this order—also known as Discalced Friars Minor or Spanish Reformed Conventuals—was a Spanish offshoot of the Franciscans.[1]

FIGURE G Plan of the Church of San Pascual Baylon, Aranjuez, Spain. From *I desegni di architettura dell'Archivio storico dell'Accademia di San Luca* (Rome, 1974), vol. II: no. 2143.

FIGURE H Facade of the Church of San Pascual Baylon, Aranjuez, Spain. Photo: Madrid, Patrimonio Nacional.

The pioneering research of Catherine Whistler on the Spanish phase of Tiepolo's career has revealed the full complexity of the Aranjuez commission.[2] In 1762, the king persuaded the artist to come to Madrid to paint the vast ceilings of the Palacio Real, and Tiepolo evidently sought the Aranjuez commission just after he and his studio had completed these frescoes. The new project—a set of unified altarpieces for a large church—was unlike anything the artist had taken on and marked Tiepolo's turn to public, ecclesiastical painting in Spain. He received the commission for seven altarpieces in March 1767. The artist quickly completed five presentation sketches—there are no records of sketches for *Saint Anthony of Padua with the Christ Child* (fig. I) and *Saint Peter of Alcántara* (fig. J)—and the king bestowed his

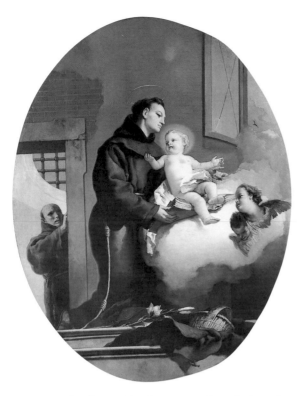

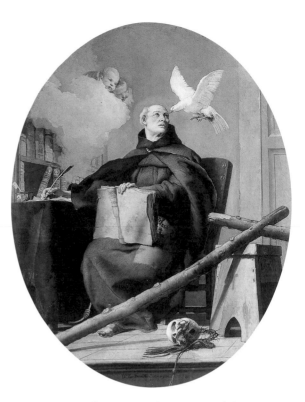

FIGURE I Giambattista Tiepolo. *Saint Anthony of Padua with the Christ Child*, 1769. Oil on canvas. Madrid, Museo Nacional del Prado. All rights reserved © Museo Nacional del Prado, Madrid.

FIGURE J Giambattista Tiepolo. *Saint Peter of Alcántara*, 1769. Oil on canvas. Madrid, Palacio Real.

formal approval for Tiepolo to move forward on the altarpieces in August of that same year. Granted a larger studio in Madrid, which he would need to produce the enormous canvases, Tiepolo and his atelier worked on the seven paintings for the next two years. With his characteristic efficiency he completed the series of paintings before construction of the church had even finished. The works remained in Tiepolo's studio and were installed only in May 1770, two months after the artist's death.

Joaquín de Eleta, the king's confessor and himself an Alcantarine, oversaw the commission. Profoundly committed to royal protocol, Eleta prevented the artist from submitting the sketches directly to the king and closed off any direct contact with the court regarding the commission. For an artist such as Tiepolo, who had decades of experience as a court artist and who had regularly engaged in close communication with his patrons, the layers of bureaucracy involved in the Aranjuez commission were particularly galling. Yet Charles III carefully monitored the details of the commission, and Eleta only served as intermediary between the king and the artist and did not actively participate in iconographic and aesthetic decisions.[3]

The court evidently selected the subjects of the altarpieces. The church's titular saint and a key Alcantarine figure, Saint Pascal Baylon (1540–1592), was the subject of the high altar, *Saint Pascal Baylon's Vision of the Eucharist*. The transept altars were to present two key Franciscan subjects, the Immac-

ulate Conception at left and Saint Francis of Assisi receiving the stigmata at right. In the nave at left would be Saint Joseph with the Christ Child, followed by a smaller oval altarpiece of Saint Peter of Alcántara, both important Alcantarine subjects. On the opposite wall would hang a painting of the king's name saint and a protector of the Franciscans, Saint Charles Borromeo, shown venerating the Crucifix, along with a smaller work portraying a familiar Franciscan saint and subject, Saint Anthony of Padua with the Christ Child.

The seven altarpieces address the key concerns of eighteenth-century Franciscans and express the particular spiritual identity of the Alcantarines. They articulate themes central to Franciscan piety: devotion to Christ (Joseph, Francis of Assisi, and Anthony of Padua), to the Eucharist (Pascal Baylon, Charles Borromeo, and Peter of Alcántara), and to the Immaculate Virgin. The altarpieces advocate both the active life (such as the Imitation of Christ by Pascal Baylon and Francis of Assisi and the protection of the Infant Christ by Joseph) and the contemplative life (the vision of Anthony of Padua and the prayer of Charles Borromeo).[4] More generally, these works depart from the dramatic, hearty voice that had exemplified Tiepolo's earlier religious paintings; a spirit of unprecedented austerity and economy marks both the sketches and the final compositions. This restraint gives the ascetic piety of the Aranjuez friars a visual form, but it also marks the advent of a new, more personal approach to image-making in the twilight of the artist's career.

Soon after the installation of the paintings, Charles III elected to replace them with another set of altarpieces, depicting exactly the same subjects, by Anton Raphael Mengs (1728–1779), Mariano Salvador Maella (1739–1819), and Francisco Bayeu (1734–1795). Tiepolo's altarpieces hung until the new paintings were completed and mounted in 1775; they were then transferred to the associated convent. The fate of Tiepolo's commission, for many scholars, stemmed from the rivalry in the Spanish court between Tiepolo and the Saxon artist Mengs, an agon between the late Baroque tradition represented by Tiepolo and the new classicizing approach represented by Mengs. But such an interpretation misreads the relationship between the artists as well as the reception of Tiepolo's works in Spain.[5] Tiepolo and Mengs did not consider themselves in competition; in fact, they were rarely in Madrid at the same time, remained cordial, and held different positions at court. Moreover, Tiepolo's ceilings were received with unreserved enthusiasm in Spain, and he received a major ceiling commission on the heels of the Aranjuez commission.[6]

Tiepolo's iconography and interpretation of the subject matter were not in themselves disturbing to the monarch.[7] Indeed, a comparison of Tiepolo's *Saint Pascal Baylon's Vision of the Eucharist* (cat. no. 9) with the later interpretation of the subject by Mengs (fig. K) demonstrates their similar approaches to the subject. The problem was that the language Tiepolo used for religious painting jarred with the taste of the king and led him to reject the altarpieces.[8] The ecstatic, emotive spirituality presented by Tiepolo— accentuated by the very spareness of the paintings—was diametrically op-

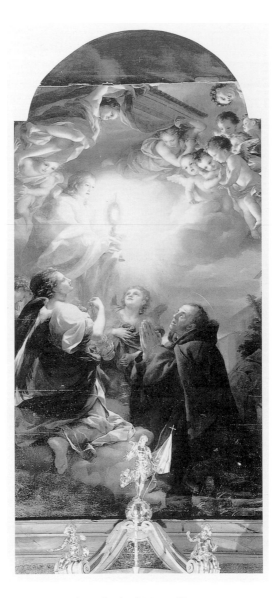

FIGURE K Anton Raphael Mengs (German, 1728–
1779). *Saint Pascal Baylon's Vision of the Eucharist*, 1776.
Oil on panel. Aranjuez, Spain, Church of San Pascual
Baylon. Photo: Madrid, Patrimonio Nacional.

posed to Mengs's restrained approach to ecclesiastical painting, which
Charles III enthusiastically embraced. The king owned numerous easel pic-
tures on religious themes by Mengs, and he considered the grave, more
sculptural Roman language of these images to be the appropriate mode for
religious painting.[9] The work of Mengs consciously drew on the canon of
Western art, providing a sense of universality and investing these sober images
with the authority of Rome that was so important to Charles III. In the end,
the very inventiveness, individual feeling, and otherworldliness of Tiepolo's
paintings may have led the king to reject them. Their Venetian religious sen-
sibility, suffused with sentiment and mysticism, was at odds with a commis-
sion designed to express the king's orthodoxy.

Tiepolo's altarpieces stood for years in the convent adjacent to the church and were ultimately dispersed in the early nineteenth century. The quality of the final canvases is often disparaged, but several of these altarpieces—such as *The Immaculate Conception* (fig. 10.1)—stand among his greatest ecclesiastical works. Nonetheless, other paintings are less inspired in their final form, in some cases because of the heavy hand of studio assistants, in others because of serious damage to the works. The sketches, on the other hand, stand among the most remarkable examples of religious art in the late eighteenth century. They are masterpieces of this artist's late style, at once noble and restrained, as well as deeply personal expressions of a visionary spirituality.[10]

NOTES

1 The Alcantarines later joined with other Observant friars to form the Order of Friars Minor, a currently active order.

2 This essay depends heavily on Catherine Whistler's many crucial contributions, including the accurate chronology of events. See especially Whistler 1984; Whistler 1985b; Whistler 1986; Christiansen 1996 (entries by Whistler), 194, 196–97, 242–53; and Whistler 1998.

3 For the relationship of Eleta and Tiepolo, see Whistler 1984, 99–103; and Whistler 1985b, 202. Eleta's staunch allegiance to protocol led him to eschew direct communication with Tiepolo. The artist was required to communicate to Eleta through Francesco Sabatini (1721–1797), the king's architect and the overall head of the Aranjuez project. Documents suggest that Tiepolo mistakenly believed that Eleta had decision-making powers. For Tiepolo's correspondence, see G. B. Urbani de Gheltof, "Tiepolo in Ispagna," *Bolletino de arti e curiosità veneziane* (1880): 174, 180.

4 Whistler 1984, 323; Whistler 1998, 72–73.

5 Whistler 1984, 108, 159–62; Whistler 1986, 199–201.

6 For Tiepolo's final fresco commission, see Whistler 1985a. For another case study of illusionistic Baroque ceiling painting coexisting with rigorously classicizing easel painting, consider the late eighteenth-century redecoration of the Villa Borghese in Rome (see Carole Paul, "Mariano Rossi's Camillus Fresco in the Villa Borghese," *Art Bulletin* 74 (1992): 297–326).

7 The friars of Aranjuez appear to have had no substantive contribution to the debate, and their opinions on the vicissitudes of Tiepolo's work for their church remain unclear.

8 Whistler 1984, 379–80; Whistler 1985b, 325–26.

9 On Anton Raphael Mengs's religious paintings for Madrid, see Steffi Roettgen, *Anton Raphael Mengs, 1728–1779*, 2 vols. (Munich: Himmer Verlag, 1999), 1:143–47, and 2:351–54; the entry by Steffi Roettgen in Bowron and Rishel 2000, 410–11; and especially José Luis Sancho and Javier Jordán de Urríes y de la Colina, "Mengs e la Spagna," in *Mengs: La scoperta del Neoclassico*, exhibition catalogue, edited by Steffi Roettgen (Venice: Marsilio, 2001), 70–85.

10 For the critical response to the sketches, see Whistler 1984, 52.

1767
Oil on canvas
63.7 × 38.9 cm (25⅛ × 15¼ in.)
The Samuel Courtauld Trust at the Courtauld Institute Gallery,
Courtauld Institute of Art, London; inv. 454

PROVENANCE

Probably retained by Giambattista
Tiepolo in his studio; upon his death,
probably by inheritance to his son,
Giandomenico Tiepolo; probably sold
to Francisco Bayeu, Madrid, 1770–95;
upon his death, held in trust by the
estate; sold to Leonardo Chopinot,
Madrid, 1795–1800; by inheritance to
his wife, 1800; Hulot collection,
1800; sold, Galerie Georges Petit, Paris,
May 10, 1892, lot 141; private collection,
Brazil; sold, Milan, 1937, to Count
Antoine Seilern, London; by bequest
to the Home House Trustees for the
Courtauld Institute of Art, University
of London, 1978.

EXHIBITIONS

Venice 1951, no. 98; London 1954–55,
no. 500; London 1960, no. 412.

BIBLIOGRAPHY

Mayer 1935, 300 (illus.); Coletti 1936,
170–71 (illus.); Fiocco 1942, 8, fig. 4;
Morassi 1943, 38, fig. 126; Sánchez
Cantón 1949, 632; Morassi 1950, 206;
Lorenzetti 1951, 130–31, fig. 98;
Pallucchini 1951, 382; Pignatti 1951,
147, 150–51, fig. 112; Vigni 1951, fig. 124;
Saltillo 1952, 76; Sánchez Cantón 1953,
19, 24, fig. 17; Morassi 1955a, 37,
fig. 63; Seilern 1959, 162, pl. CXXXV;
Crivellato 1960, 79; Levey 1960a,
123; Crivellato 1962, 89; Morassi 1962,
20–21; Gaya Nuño 1964, 94, fig. 112;
Piovene and Pallucchini 1968, 134–35,
fig. 299a; Rizzi 1971, 1:143, 152, fig. 87;
Seilern 1971a, 57–58; Knox 1980, 1:328;
Levey 1980, 236; Braham 1981, 76–77,
fig. 111; Whistler 1984, 303–4, 323–57;
Whistler 1985b, 323; Levey 1986,
272–74, 277; Bradford and Braham
1989, 25; Farr, Bradford, and Braham
1990, 70–71; Brown 1993, 40, 318–21,
fig. 59; Gemin and Pedrocco 1993,
308–9, fig. 281.1.a; Whistler 1998,
71, 74, 78, fig. 8; Pedrocco 2002, 491,
fig. 519a.

P ASCAL BAYLON (1540–1592) IS AN IMPOR-
tant Spanish saint associated with the
Alcantarine order as well as the titular saint of
the church in Aranjuez. Born in poverty and
receiving only a rudimentary education, Baylon
spent his youth as a shepherd, devoted to soli-
tude and contemplation as well as acts of charity.
As a young man he developed a powerful devo-
tion to the Eucharist and experienced regular
ecstatic visions. In 1564 he joined the Alcan-
tarines, a rigorous reform movement within the
Franciscan order, but he insisted on retaining
his highly personal form of extreme humility,
remaining a shepherd and associating with the
laity rather than the priests of his order.

In Tiepolo's sketch, Pascal Baylon, in black
Alcantarine robes, kneels before a vision of the
Eucharist. He gazes upward at an angel, who
descends with a cluster of cherubim and holds
the Host in a sumptuous gilt monstrance.
Behind the saint stands a monumental portico
that resembles the Roman baroque facade of the

newly constructed church in Aranjuez.[1] In con-
trast to this imposing backdrop, a humble
wooden fence extends across the canvas, sepa-
rating the cleric from the edifice, and a hoe
and sack lie in the foreground. These details
mark the saint's famous humility and rejection of
priestly activities. At the same time the saint's
prayer in the church garden creates an unmistak-
able parallel with Christ's agony in the Garden
of Gethsemane.

The color scheme further valorizes Baylon's
humility by accentuating the sharp contrast
between his asceticism and his vision of splendor.
The saint's monochrome garment and the drab,
arid garden are juxtaposed with the bright,
flickering whites of the angel's wings and silken
robe. The angel's vestment—a highly saturated
yellow humeral cloth, lined in rose—provides
the coloristic focal point of the painting.

Tiepolo attended to the finish of this work
more than he did to the other sketches for
Aranjuez, such as *Saint Francis of Assisi Receiving*

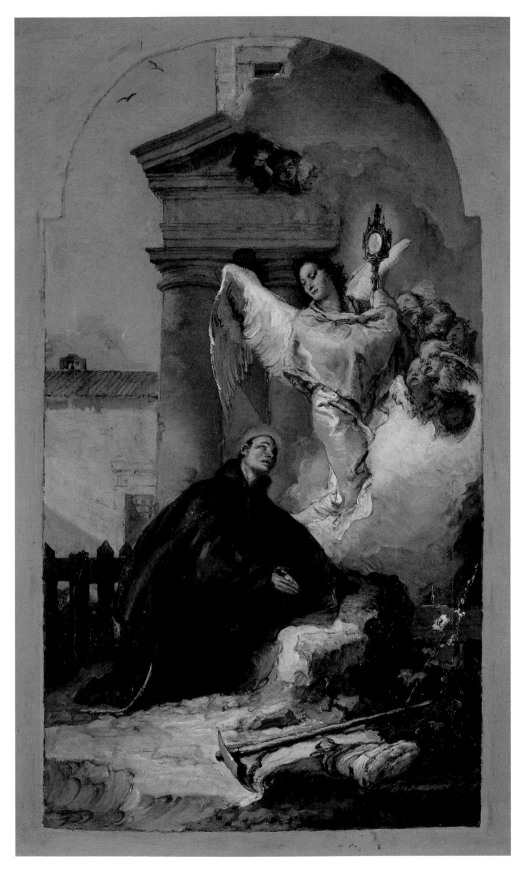

CAT. NO. 9

the *Stigmata* or *Saint Charles Borromeo Meditating on the Crucifix* (cat. nos. 11–12). Even so, he executed the painting with his customary economy of means, applying a second layer of reddish brown ground over the putty undercoat, and then using this warm tone for the shadows in the flesh tones. He also sketched extensively in brown pigment, defining the architecture, for example, with ragged painted lines. Although he applied paint rather thickly in passages, Tiepolo still used only one or two strata, laid in wet-on-wet, to create form and shadow. For additional depth and complexity he used layers of glazes, especially on the humeral veil and the faces, particularly that of the angel.

The two extant fragments in the Prado (figs. 9.1–2), and a print by his son Giandomenico (fig. 9.3), reveal small changes to the saint in the final composition. His pose is now more erect, and Tiepolo used shadows to ground the saint more convincingly. Tiepolo also moved the hoe closer to Pascal Baylon and transformed the amorphous sack into a basket to accentuate his pastoral vocation. The angel underwent more significant revisions, first worked out in a drawing now in the Courtauld (fig. 9.4). The artist aligned the angel's head and spine, and he abandoned the humeral veil, baring the angel's right arm and using a more complex pattern of folds, colors, and shadows in the garments. The angel also now holds a cloth around the base of the chalice. These relatively minor alterations transform the tone of the work considerably, moving from the more intimate relationship of the figures in the sketch to the grander experience of the finished work. This shift, as the Palazzo Sandi sketch also demonstrates (cat. no. 1), remains in keeping with Tiepolo's practice of heightening the formality in his public compositions from his initial, personal oil sketches and drawings.

While Tiepolo may have altered the humeral cloth for compositional reasons (to add more variety to the figure), the shift may also owe a debt to ecclesiastical demands.[2] The angel bearing the Eucharist with a humeral cloth implies the sacrament of communion, an unorthodox representation (and one not specifically described in sources recounting Pascal Baylon's visions). Clerical interventions of this type took place regularly in Spain (for example, the rejection of the *Saint James of Compostella* altarpiece for the

FIGURE 9.1 Giambattista Tiepolo. Fragment of *Saint Pascal Baylon's Vision of the Eucharist*, 1767–69. Oil on canvas. Madrid, Museo Nacional del Prado. All rights reserved © Museo Nacional del Prado, Madrid.

FIGURE 9.2 Giambattista Tiepolo. Fragment of *Saint Pascal Baylon's Vision of the Eucharist*, 1767–69. Oil on canvas. Madrid, Museo Nacional del Prado. All rights reserved © Museo Nacional del Prado, Madrid.

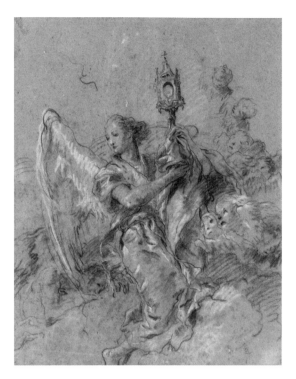

FIGURE 9.3 Giandomenico Tiepolo (Italian, 1727–1804), after Giambattista Tiepolo. *Saint Pascal Baylon's Vision of the Eucharist*, ca. 1770. Engraving. Venice, Museo Correr.

FIGURE 9.4 Giambattista Tiepolo. Study for *Saint Pascal Baylon's Vision of the Eucharist*, 1767–69. Red and white chalk. The Samuel Courtauld Trust at the Courtauld Institute Gallery, Courtauld Institute of Art, London.

Spanish Embassy in London), opening up the possibility of such an imposed change.[3]

A comparison with *Saint Luigi Gonzaga in Glory* (cat. no. 3), an early work that also depicts a private vision of the Eucharist, demonstrates the immense evolution that Tiepolo's handling and treatment of anatomy underwent over four decades. It also reveals the particular iconographic and spiritual demands of the Aranjuez commission. From the disembodied vision, flickering brushwork, hyperrefined and elongated bodies, and unexpected color contrasts of the early sketch, Tiepolo moved to a reified vision, a restrained and monumental composition, and a unified palette with quieter brushwork. While this nobility and restraint speak to the formal changes across the artist's long career, *Saint Pascal Baylon's Vision of the Eucharist* also shows the painter explicitly responding to the severity associated with Alcantarine commisions and the eighteenth-century Catholic reforms of that were supported by his royal patron. Tiepolo presents the vision of the Host as a concrete event and emphasizes

the setting, aspects particularly important for paintings designed for a king who had recently expelled the Jesuit order, aimed to downplay mysticism, and imposed Enlightenment values on the Church. While Tiepolo filtered these ideas through his unique personal language, the paintings demonstrate his awareness of the new mode of religious painting fostered especially by Mengs and reveal Tiepolo's inventive approach to new patronal demands, even at the end of his long career. ❧

NOTES

1 Whistler 1985b, 321–33.
2 A suggestion first made by Michael Levey (1960, 123). Keith Christensen (1996, 247n.3) correctly notes that the substitute altarpiece by Mengs shows the angel with the monstrance in a humeral veil (see fig. K, p. 62). The possibility exists, however, that the ecclesiastical demands might have been handed out unevenly, especially given the general dissatisfaction that met Tiepolo's final altarpieces. Moreover, the humeral veil has a far greater prominence in Tiepolo's sketch.
3 Entry by Catherine Whistler in Christiansen 1996, 231.

10 *The Immaculate Conception*

1767
Oil on canvas
63.7 × 38.9 cm (25⅛ × 15¼ in.)
The Samuel Courtauld Trust at the Courtauld Institute Gallery,
Courtauld Institute of Art, London; inv. 451

PROVENANCE

Probably retained by Giambattista Tiepolo in his studio; upon his death, probably by inheritance to his son, Giandomenico Tiepolo (1727–1804); probably sold to Francisco Bayeu (1734–1795), Madrid, 1770–95; upon his death, held in trust by the estate; sold to Leonardo Chopinot, Madrid, 1795–1800; by inheritance to his wife, 1800; George William Fox, ninth baron Kinnaird, Rossie Priory, Perthshire, by 1826–78; by inheritance to his grandson, Arthur Fitzgerald, 1878–1923, eleventh baron Kinnaird; by inheritance to his son, Kenneth Fitzgerald. 1923–1967, twelfth baron Kinnaird; sold to Count Antoine Seilern (1901–1978), London, 1967; by bequest to the Home House Trustees for the Courtauld Institute of Art, University of London, 1978.

EXHIBITIONS

London 1954–55, no. 498; London 1963–64, no. 5; London 1989, no. 12.

BIBLIOGRAPHY

Sack 1910, 226; Saltillo 1952, 76; Knox 1955, 37–39, fig. 12; Morassi 1955a, 37; Morassi 1955b, 11, fig. 1; Watson 1955, 262–63, fig. 296; Morassi 1962, 19; Piovene and Pallucchini 1968, 134–35, fig. 299b; Seilern 1969, 29, pl. XXII; Rizzi 1971, 1:143, 150, figs. 85–86; Knox 1980, 1:328; Braham 1981, 77, fig. 112, pl. XIV; Levey 1986, 273–76, 279, fig. 229; Farr 1987, 64–65; Bradford and Braham 1989, 25; Helston 1989, 58–59, fig. 12; Farr, Bradford, and Braham 1990, 68, 70 (illus.); Gemin and Pedrocco 1993, 492, fig. 520a; Christiansen 1996, 242, 244, 246–47, fig. 40a; Giambattista Tiepolo 1998, 117, 241, fig. 123; Whistler 1998, 71, 76–77, 84, fig. 14; Pedrocco 2002, 308–9, fig. 281.2.a; Derstein 2005.

STANDING ON A GLOBE AND A CRESCENT moon with a serpent squirming underfoot, the Virgin Mary rises heavenward in a glowing, yellowish ocher sky, accompanied by a swarm of angels, putti, and cherubim. The only female protagonist in Tiepolo's series of altarpieces in the church at Aranjuez, the Virgin also stands apart from the other saints because of her imposing monumentality and emotional distance. While the other works for San Pascual Baylon present ardent interactions between the saints and their visions or objects of prayer, this canvas offers an image of overwhelming grandeur. The compositions of the other paintings unfold along diagonals; in this one, the Virgin ascends in a commanding vertical and is the only figure in the series to dominate the upper half of the canvas. Without lowering her chin, she gazes grandly downward at the worshiper, and her erect stance, abstracted pose with hands clasped in prayer, and blue mantle billowing outward create an image of stately, serene authority.

The handling of this work is immensely sophisticated; it is largely painted in summary daubs of opaque pigment, with dark lines of paint defining the elaborate folds of the Virgin's complex drapery. Tiepolo applied passages of delicate glazes, especially in the lower half of the sketch, such as in the rose cloth surrounding the putto at lower left. The lapis glaze of cherub's wings at right is an especially luxurious touch, speaking to the level of refinement of these presentation *modelli*.

Tiepolo brought a touching humanity to the historical figures depicted in the other paintings in the church, but for *The Immaculate Conception* he sought to represent, by contrast, an abstract theological idea, and for that reason the Virgin appears as an iconic, commanding figure. The Immaculate Conception—the belief that the Virgin Mary was born free of Original Sin— would not become fully accepted Catholic dogma until 1854. But the Immaculate Conception had begun to be incorporated into Christian

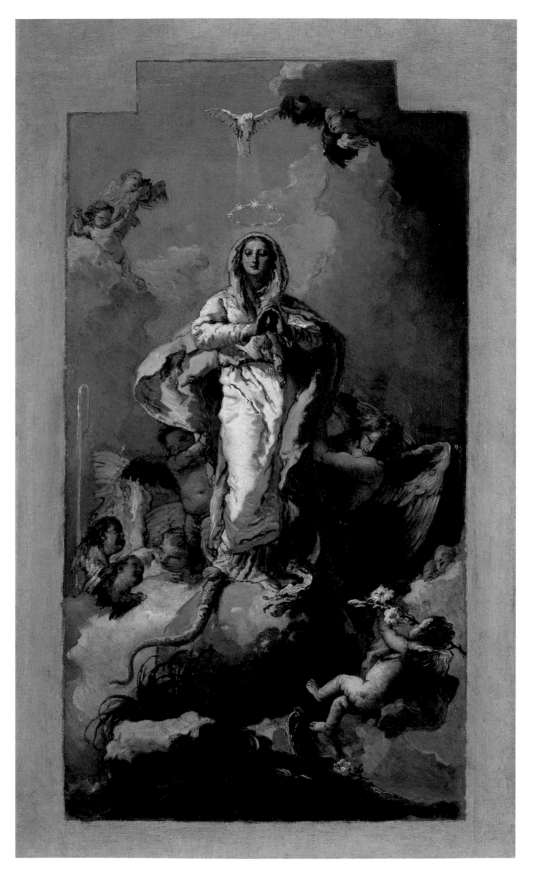

CAT. NO. 10

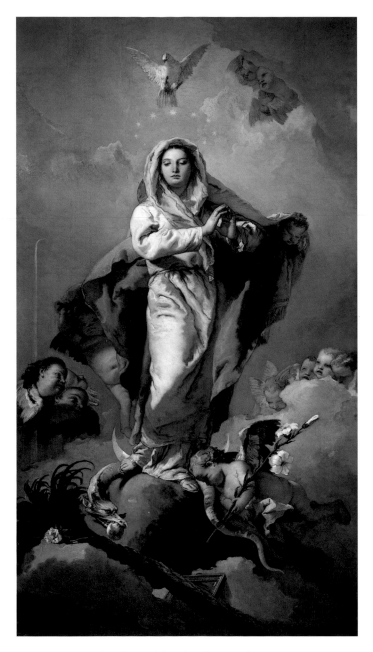

FIGURE 10.1 Giambattista Tiepolo. *The Immaculate Conception*, 1767–69.
Oil on canvas. Madrid, Museo Nacional del Prado. All rights reserved ©
Museo Nacional del Prado, Madrid.

liturgy as early as 1128 and made important
inroads in the sixteenth and seventeenth cen-
turies, although it remained highly controversial,
even in the eighteenth century. Its prominent
presence in Aranjuez stemmed from the special
vigor with which the Franciscan order advocated
the Immaculate Conception, as well as the
dogma's massive popularity in Spain, particularly
among its monarchs, including Charles III.[1]

The imagery of the Immaculate Conception
coalesced in the sixteenth century, and Spanish
artists established its definitive iconography dur-
ing the early seventeenth century. This repre-
sentation merged the early tradition of depicting
Mary among symbols of immaculacy with the
Virgin of the Apocalypse, and Tiepolo drew on
this conjoined typology for the Aranjuez altar-
piece. Symbols of immaculacy—many drawn

70

from the Song of Songs—surround the Virgin. The rose and flawless mirror signify purity; the palm symbolizes victory; and the obelisk drawn in white at left recalls the comparison of the Virgin's neck to the tower of David, impregnable and pure.[2] The crown of stars, crescent moon, and serpent all derive from Revelation 12, which describes the Woman of the Apocalypse who triumphs over the original sin of Eve (the serpent carries an apple in its mouth) to become the pure vessel of Christ.

In the altarpiece Tiepolo further heightened the abstract majesty of the figure (fig. 10.1). He increased the relative proportion of the Virgin to the overall picture plane and brought Mary closer to the top of the canvas by reducing the space between the dove and the Virgin's crowned head. Tiepolo also expanded the Virgin's cloak outward, surrounding her with more shadows and thereby increasing the monumentality of the overall composition. In the final painting Tiepolo eliminated the strapping angel, who raised Mary up in the sketch, in order to emphasize the Virgin's agency in her ascent. The flashing, nervous brushwork of the sketch gives way to the more even handling of the altarpiece, and the contrast between the brightly glazed passages and the earth tones moves to a more modulated overall palette.

Tiepolo no doubt knew of precedents for the iconography in Spain—such as the prominent examples by Guido Reni (now in the Metropolitan Museum of Art) and Bartolomé Esteban Murillo (now in the Prado)—which depicted a delicate and beautiful young girl. He had represented the Virgin long before his arrival in Spain, both as a figure incorporated into larger compositions (cat. no. 8) and as an independent subject, with versions in Amiens (fig. 10.2), Vicenza, Dublin, Udine, and Detroit.[3] The stately, placid Virgin had considerable precedent in Tiepolo's oeuvre (see cat. no. 2 for a related type, the Madonna of the Rosary). However, in both the Courtauld sketch and the Prado altarpiece, Tiepolo transformed these prior representations into a totem of strength and orthodoxy. ❧

FIGURE 10.2 Giambattista Tiepolo. *The Immaculate Conception*, ca. 1732–34. Oil on canvas. Amiens, France, Musée de Picardie. Photo: Marc Jeanneteau.

NOTES

1 For the iconography of the Immaculate Conception, the key source remains Mirella Levi d'Ancona, *The Iconography of the Immaculate Conception in the Middle Ages and Early Renaissance*, Monographs on Archaeology and Fine Arts, 7 (New York: College Art Association of America in conjunction with the *Art Bulletin*, 1957). For the Immaculate Conception in Spain, see especially Suzanne L. Stratton, *The Immaculate Conception in Spanish Art* (Cambridge: Cambridge University Press, 1994).

2 The reference to the Tower of David comes specifically from Song of Songs 4:4: "Your neck is like the tower of David, built for an arsenal, whereon hang a thousand bucklers, all of them shields of warriors" (RSV).

3 For these works, see Pedrocco 2002, 234, 301, 314.

1767
Oil on canvas
63.5 × 28.9 cm (25 × 11⅜ in.)
The Samuel Courtauld Trust at the Courtauld Institute Gallery,
Courtauld Institute of Art, London; inv. 455

PROVENANCE

Probably retained by Giambattista
Tiepolo in his studio; upon his death,
probably by inheritance to his son,
Giandomenico Tiepolo (1727–1804);
probably sold to Francisco Bayeu
(1734–1795), Madrid, 1770–95; upon
his death, held in trust by the estate;
sold to Leonardo Chopinot, Madrid,
1795–1800; by inheritance to his wife,
1800; Anatole-Auguste Hulot
(1811–1891), Paris; upon his death,
probably held in trust by the estate;
sold, Galerie Georges Petit, Paris,
May 10, 1892, lot 141; private collection,
Brazil, by 1935; private collection,
Milan, by 1936; sold to Count Antoine

Seilern (1901–1978), London, 1937; by
bequest to the Home House Trustees
for the Courtauld Institute of Art,
University of London, 1978.

EXHIBITIONS

Venice 1951, no. 99; London 1954–55,
no. 507; London 1960, no. 419; London
1989, no. 13.

BIBLIOGRAPHY

Mayer 1935, 300 (illus.); Coletti 1936,
370–71 (illus.); Fiocco 1942, 8, fig. 3;
Morassi 1943, 38, fig. 127; Sánchez
Cantón 1949, 633; Lorenzetti 1951,
131–32, fig. 99; Vigni 1951, fig. 125;
Saltillo 1952, 76; Sánchez Cantón 1953,

19–20, fig. 24; Morassi 1955a, 37,
pl. 91; Seilern 1959, 163, pl. CXXXVI;
Crivellato 1960, 79; Morassi 1962,
20, 22; Gaya Nuño 1964, 94, fig. 111;
Piovene and Pallucchini 1968, 134–35,
fig. 299c; Rizzi 1971, 1:143, 152, fig. 89;
Seilern 1971a, 57–58; Knox 1980, 1:328;
Braham 1981, 75, 78, fig. 113; Whistler
1985b, 323; Levey 1986, 272–74, 276,
279, fig. 232; Bradford and Braham
1989, 25; Helston 1989, 60–61, fig. 13;
Brown 1993, 41, 319, fig. 12; Gemin
and Pedrocco 1993, 492, fig. 521a;
Christiansen 1996, 196–97, 248–49, 253,
fig. 41a; Whistler 1998, 71, 74–75,
77, 79, fig. 77; Pedrocco 2002, 308–9,
fig. 281.3.a.

I T IS NO SURPRISE THAT AN ALTARPIECE depicting the founding saint of the Franciscan order would play a prominent part in the Alcantarine, or Discalced Franciscan, program at Aranjuez. For this work Tiepolo drew upon the most common representation of Francis of Assisi, with myriad precedents in the history of art: the moment when he received the stigmata in 1224 on La Verna in Tuscany.

Tiepolo himself had painted the subject early in his career, but this work —known only from a print (fig. 11.1) —presented a highly energized figure, thrust backward into the viewer's space by the explosive event. In sharp contrast, Tiepolo adopted a profoundly introspective approach for his touching interpretation of the subject for Aranjuez.

In the sketch, Francis of Assisi (1181–1226) reclines on a straw mat draped over a boulder. His eyes, barely open, register little awareness of the half-nude angel with gleaming white wings and a flowing saffron robe who gracefully

attends him. Francis instead looks upon a makeshift crucifix, no more than a slender stick, leaning away from him and out of the picture frame. As his companion Leo kneels in prayer at the foot of the cross, the saint weakly holds out his hands while an eight-winged cherub emits thin bands of light (now rather abraded) that reach down to Francis to create the imprints of Christ's Passion on his body.

In the final painting (fig. 11.2) Tiepolo clarified the composition considerably, abandoning the figure of Saint Leo and the makeshift cross to concentrate on the central relationship of saint, angel, and cherub. In closer alliance with the textual sources, the sacred event now takes place just before dawn rather than at daybreak; the deep blues of the background stand apart from the other, brightly lit altarpieces for Aranjuez. As a result the cherub gains in brightness, and this light focuses more intensely on Francis and the angel, clarifying their forms, emphasizing the lithe musculature of the angel,

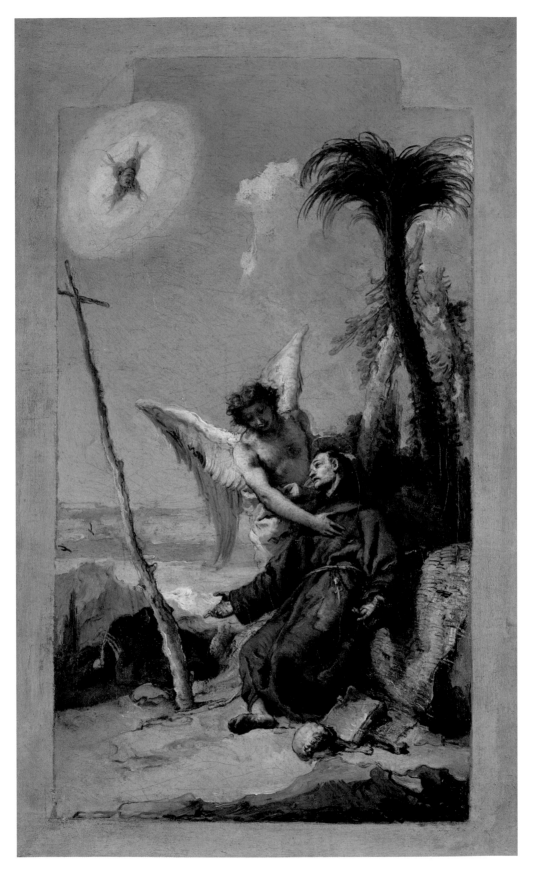

CAT. NO. 11

FIGURE 11.1 Pietro Monaco (Italian, 1710–after 1775), after Giambattista Tiepolo. *Saint Francis of Assisi Receiving the Stigmata*, ca. 1735–39. Engraving. London, The British Museum, 1865-5-20-703.

and elegantly reducing the play of folds and shadows that add such delicacy and liveliness to the sketch. Tiepolo also pulls the shadowed clump of trees at right—one of the most inventive details of the Courtauld painting—beyond the top of the canvas to anchor the composition more solidly. The artist, in other words, sought a significantly more monumental effect in the final altarpiece, playing down the more capricious details of the sketch and pulling the figures closer to the picture plane while increasing their proportions vis-à-vis the open sky above. By placing the mat on the ground and emphasizing the skull, Bible, and walking stick, Tiepolo brought the familiar attributes of the saint more into play in the final work, creating a grander, more traditional image.

Like *Saint Pascal Baylon's Vision of the Eucharist* (cat. no. 9), *Saint Francis* gains its power from the moving encounter of angel and saint. The sketch sharply contrasts the tautness of the angel's body, as well as its bright fabrics and rosy flesh (for this detail, Tiepolo skillfully exploits the pinkish ground layer), to the limp body, grayish pallor, patched chocolate brown cope, and semiconscious state of Saint Francis. In the final work Tiepolo retained this powerful distinction but altered the position of Francis so that he now gazes directly at the cherub and consciously receives the stigmata. Tiepolo worked up this alteration in a red and white chalk drawing, in which he considered the idea of posing the saint with his arms raised higher and opened wider.[1]

This change in the position of Francis from the oil sketch to the final work reveals Tiepolo's great sensitivity to contemporary religious concerns. Ecclesiastical reformers in the eighteenth century increasingly looked upon mysticism with suspicion. While Franciscans remained more open to visionary spirituality,[2] the Enlightenment-rooted reforms embraced by Charles III aimed to rein in the most extreme mystical aspects of Catholicism. Thus the restraint of Tiepolo's altarpieces for Aranjuez not only expresses the austerity of the Alcantarine order but also articulates the specific demands of Spanish Catholic reform that the San Pascual Baylon series was meant to exemplify. Tiepolo's revisions present the saint's experience as more active, moving from the swooning trance of the sketch to direct physical and mental contact with the cherubic vision in the final altarpiece.[3] He emphasized the parallel between Saint Francis and Christ by increasing the size and redness of the wound in the saint's side; he also changed the saint's facial expression from one of pure suffering to one that more clearly conveys the passionate love of Christ so central to the traditional narrative of Francis of Assisi receiving the stigmata.[4] ♣

NOTES

1 Knox 1980, 1:194, 2:pl. 60.
2 This idea needs to be explored in more depth with regard to Tiepolo's altarpieces. For example, during the eighteenth century, Spanish Franciscans were aggressively promoting the seventeenth-century mystic Sor María de Jesús de Agreda (María Fernández Coronel; 1602–1665),

FIGURE II.2 Giambattista Tiepolo. *Saint Francis of Assisi Receiving the Stigmata*, 1767–69. Oil on canvas. Madrid, Museo Nacional del Prado. All rights reserved © Museo Nacional del Prado, Madrid.

whom the papacy under Benedict XIV Lambertini (r. 1740–58) vigorously opposed because of her perceived mystical excess (on these debates, see Rosa 1999, 47–68). That Joaquín de Eleta, the Alcantarine in charge of the Aranjuez commission, was a great supporter of María de Jesús de Agreda's cause (Whistler 1998, 81, 85n.39) indicates that the emotive, visionary subjects of Tiepolo's

altars were probably in tune with the order's spiritual attitudes, if not with those of the king himself.

3 For the representation of Francis of Assisi from the late sixteenth century on, see Pamela Askew, "The Angelic Consolation of St. Francis of Assisi in Post-Tridentine Italian Painting," *Journal of the Warburg and Courtauld Institutes* 32 (1969): 280–306.

4 Entry by Catherine Whistler in Christiansen 1996, 196.

12 *Saint Charles Borromeo Meditating on the Crucifix*

1767
Oil on canvas
63.4 × 38.3 cm (24¾ × 15 in.)
The Samuel Courtauld Trust at the Courtauld Institute Gallery,
Courtauld Institute of Art, London; inv. 452

PROVENANCE

Probably retained by Giambattista Tiepolo in his studio; upon his death, probably by inheritance to his son, Giandomenico Tiepolo (1727–1804); probably sold to Francisco Bayeu (1734–1795), Madrid, 1770–95; upon his death, held in trust by the estate; sold to Leonardo Chopinot, Madrid, 1795–1800; by inheritance to his wife, 1800; private collection, Brazil, in 1935; London dealer, 1948; sold to Count Antoine Seilern (1901–1978), London, 1949; by bequest to the Home House Trustees for the Courtauld Institute of Art, University of London, 1978.

EXHIBITIONS

Venice 1951, no. 100; London, 1954–55, no. 508; London 1960, no. 417.

BIBLIOGRAPHY

Mayer 1935, 300 (illus.); Coletti 1936, 170–71; Morassi 1950, 206, 209, fig. 1; Dazzi 1951, 184; Lorenzetti 1951, 131, 133, fig. 100; Saltillo 1952, 76; *Venice* 1952, no. 72; Sánchez Cantón 1953, 19–21, fig. 26; Morassi 1955a, 37, fig. 61; Seilern 1959, 165, pl. CXXXVII; Crivellato 1960, 79; Crivellato 1962, 89; Morassi 1962, 9, 20; Gaya Nuño 1964, 93, fig. 109; Piovene and Pallucchini 1968, 134–35, fig. 299g; Rizzi 1971, 1:143, 154, fig. 90; Knox 1980, 1:328; Braham 1981, 80, fig. 115; Whistler 1984, 303–4, 323–57; Whistler 1985b, 323, 325, 327n.38; Levey 1986, 272–77, 279, 282, 295n.22; Bradford and Braham 1989, 25; Barcham 1992, 122–23, fig. 39; Brown 1993, 40, 318–21, fig. 60; Gemin and Pedrocco 1993, 495, fig. 527a; Spike 1993, 82, 84–85, fig. 30; Christiansen 1996, 242; Marini 1998, 1:102, 2:44, fig. 8; Whistler 1998, 71, 73–75, fig. 4; Pedrocco 2002, 208–10, fig. 281.7.a.

AN ANGEL HOVERING AT UPPER RIGHT pulls back a rust orange curtain to reveal Saint Charles Borromeo kneeling before an altar. Deep in meditation, the saint has crossed his arms in prayer and gazes intently on a wooden or ivory crucifix. This large object leans against the altar, energizing the work with its powerful diagonal. A monumental Veronesian structure irradiated in daylight——by far the most splendid setting for all the Aranjuez paintings—rises behind the saint. The low vantage point accentuates the grandeur of the backdrop: two colossal white columns anchor the composition at right, and a monumental arch of tan stone opens at left to a white marble balustrade in the distance.

Archbishop of Milan and founder of the Oratorians, Charles Borromeo (1534–1584) was one of the great Counter-Reformation figures. He played an important role at the Council of Trent and spearheaded key reforms, particularly in lay education and in consolidating the power of the parish. He also served as cardinal protector of the Franciscan order, and for this reason—along with the fact that he shared the name of the king—he appears in this Alcantarine altarpiece. Yet the saint's crosier, miter, and cope have been discarded at right, deemphasizing his identity as a reformer and public leader. Instead, Tiepolo presents him in the midst of a deeply personal meditation, and in this way he joins the company of the other saints depicted by the artist at Aranjuez (cat. nos. 9 and 11).

Tiepolo took great care to align this composition with the other canvases for San Pascual Baylon. In particular, the architectural setting of this altarpiece relates closely to that of *Saint Pascal Baylon's Vision of the Eucharist* (cat. no. 9), and the two works were clearly meant to be understood in tandem, divided into a system of structural opposites.[1] Tiepolo juxtaposed the Lombard's noble origins and civic status with

CAT. NO. 12

the Spanish saint's humility; he contrasted the magnificence, coloristic richness (note how Borromeo's rich fabric compares to his monochrome crucifix), indoor setting, and meditative contemplation of Charles Borromeo with the plainness, humble convent garden, and ecstatic spirituality of Pascal Baylon.

While Tiepolo summarily blocked in the ancillary details (the architecture has simply been scratched into the surface), he paid considerable attention to the color scheme, especially the symphony of reds, with subtle gradations uniting the pinks and crimsons of Charles Borromeo's garments with the altar cloth, the carpet covering the stairs, the seat cover at right, and the dusty rose fabric swirling around the angel. For the saint himself, Tiepolo sought such a saturated intensity that visible particles of pigment appear in the surplice.

Two preparatory drawings exist, including a red chalk drawing for the cherubim at lower left[2] and a black chalk study of the saint's garments (fig. 12.1). The latter sheet depicts Charles Borromeo kneeling upright, with his proper right arm and shoulder raised higher than in the present work. A prominent pentimento—including a double halo—appears behind the cleric's head and left shoulder in the painting, and X rays reveal that the saint originally held his left hand over the crucifix. These details—rare instances of Tiepolo altering a painted sketch—indicate that he revised the composition directly on the canvas. The Albertina drawing (fig. 12.1) likely served as an intermediate stage in that process. In reworking the oil sketch the artist made further changes, ultimately leaning the saint slightly forward and sinking his arm behind the crucifix, alterations that forge an even greater sense of intimacy between the saint and the object of his veneration.

Only one fragment of the altarpiece itself survives, a large section depicting the saint's head and torso and the crucifix (fig. 12.2). The flatness of this work (which may also derive from an aggressive relining), as well as the finicky handling of the lace and facial features (a candle is also introduced, which interrupts the intense gaze that connects the saint and the crucifix), suggests significant contributions by Tiepolo's studio to the final painting.

FIGURE 12.1 Giambattista Tiepolo. Study for *Saint Charles Borromeo Meditating on the Crucifix*, ca. 1769. Black chalk with white gouache on paper. Vienna, Graphische Sammlung Albertina (32968).

This work was the only one in the series by Tiepolo never to be mounted in San Pascual Baylon. Between the time of Tiepolo's commission for the full-scale altarpiece and the mounting of the pictures, the chapel received a new dedication to the Crucifixion, and a crucifix went up in the painting's place. When Maella and Bayeu executed the altarpieces in the mid-1770s, to replace those by Tiepolo, no commission came for a new version of the subject. The rejection may have come, not from Tiepolo's interpretation, but from religious politics in late eighteenth-century Spain that rendered Charles Borromeo a particularly controversial figure. The saint had consistently been celebrated as a reformer from the late sixteenth century forward, and he grew increasingly popular among Jansenist sympathizers in the eighteenth century, who saw Borromeo as a precursor of the austere, parish-based, decentralizing reforms they advocated. A key Spanish Jansenist, Bishop José Climent, had particularly identified himself with Charles Borromeo, even as he clashed with Spanish authorities in the 1760s. For these reasons the subject may have become too controversial for the king's first major ecclesiastical commission.[3] ♣

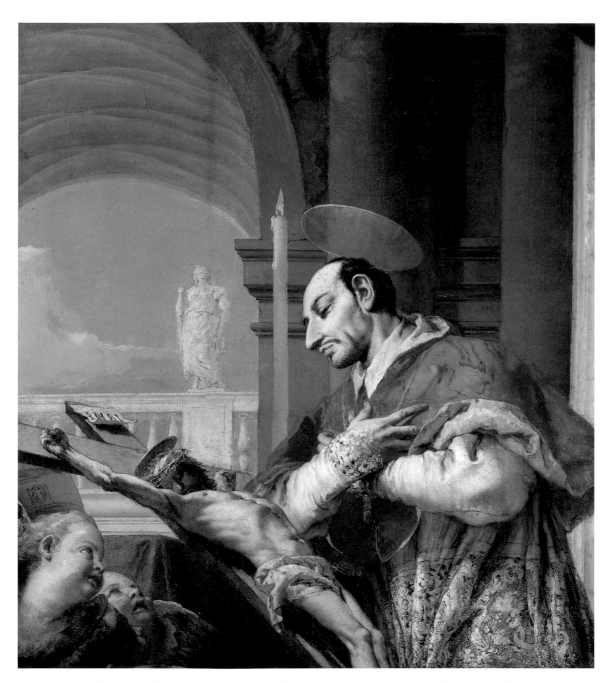

FIGURE 12.2 Giambattista Tiepolo. Fragment of *Saint Charles Borromeo Meditating on the Crucifix*, 1767–69. Oil on canvas.
Cincinnati Art Museum, John J. Emery Fund, 1924.178.

NOTES

1 Brown 1993, 320–21.

2 Knox 1980, 1:193; George Knox, "Tiepolo Drawings
from the Saint-Saphorin Collection," in *Atti del Congresso
internazionale di Studi sul Tiepolo con un'appendice sulla
Mostra* (Udine: Electa, 1970), 62, fig. 10.

3 Whistler 1985b, 325. Charles Borromeo's role in Spain
under Charles III merits more investigation, especially
since the idea of royal circles rejecting Borromeo
as the subject for an altarpiece is seriously called into
question by the dedication of the hospital across the
street from San Pascual Baylon to Charles Borromeo
in the 1770s.

13A *Saint Joseph with the Christ Child*

1767
Oil on canvas
63.2 × 33.6 cm (24⅞ × 13¼ in.)
The Samuel Courtauld Trust at the Courtauld Institute Gallery,
Courtauld Institute of Art, London; inv. 453

PROVENANCE

Probably retained by Giambattista
Tiepolo in his studio; upon his death,
probably by inheritance to his son,
Giandomenico Tiepolo (1727–1804);
probably sold to Francisco Bayeu
(1734–1795), Madrid, 1770–95; by
inheritance to his wife, 1800; possibly
private collection, South America,
nineteenth century; sold to Count
Antoine Seilern (1901–1978), London,
1949; by bequest to the Home House
Trustees for the Courtauld Institute of
Art, University of London, 1978.

EXHIBITIONS

Venice 1951, no. 101; London 1954–55,
no. 501; London 1960, no. 414.

BIBLIOGRAPHY

Morassi 1950, 206–8, fig. 12; Saltillo
1952, 76; Sánchez Cantón 1953,
19–20, fig. 22; Knox 1955, 37, 39, fig. 11;
Seilern 1959, 164, pl. CXXXVIII;
Crivellato 1960, 79; Morassi 1962,
20; Gaya Nuño 1964, 92–93, fig. 107;
Piovene and Pallucchini 1968, 134–35,
fig. 299f; Knox 1970, no. 97; Rizzi 1971,
1:143, 152, fig. 88; Seilern 1971a, 57–58;
Knox 1980, 1:194, 328; Braham 1981, 79,
fig. 114; Levey 1986, 273–74, 276–77,
279, fig. 230; Barcham 1989, 229;
Bradford and Braham 1989, 25; Brown
1993, 319, fig. 154; Gemin and Pedrocco
1993, 490, 494, fig. 524a; Whistler 1998,
71, 77, 79, 81, fig. 12; Pedrocco 2002,
308–10, fig. 281.6.a; Derstein 2005.

13B *Two Heads of Angels* (Fragment of *Saint Joseph with the Christ Child*)

1768–69
Oil on canvas
51.4 × 42.4 cm (20¼ × 16⅝ in.)
The Samuel Courtauld Trust at the Courtauld Institute Gallery,
Courtauld Institute of Art, London; inv. 343

PROVENANCE

Church of San Pascual Baylon,
Aranjuez, Spain, 1770–75; transferred
to the Convent of San Pascual Baylon,
Aranjuez, Spain, 1775–1827; Eugenio
Lucas, Madrid; Rafael García Palencia,
Madrid; Thomas Harris, Esq., London,
1928–29; F. Rothmann, Berlin; Caspari,
Munich, until 1930; M. de Frey, Paris
(who divided the fragment into two
parts); sold, June 1933, Charpentier,
Paris, no. 36; Mr. and Mrs. Heinemann,
New York; French & Co., New York;
A. and C. Canessa, Rome; sold to

Count Antoine Seilern (1901–1978),
London, 1959; by bequest to the Home
House Trustees for the Courtauld
Institute of Art, University of London,
1978.

EXHIBITIONS

None.

BIBLIOGRAPHY

Morassi 1962, 22, 31, 35, fig. 199
(as *A Cherub with Lilies and Two Heads of
Cherubim*); Piovene and Pallucchini
1968, 134–35, fig. 299f (with Prado
and Courtauld fragments combined);
Seilern 1969, 30–32, pl. XXIII; Seilern
1971a, 67; Knox 1980, 1:328; Braham
1981, 81, fig. 116; Bradford and Braham
1989, 25; Gemin and Pedrocco 1993,
490, 494, fig. 526; Christiansen 1996,
242; Pedrocco 2002, 308–10, fig.
281.6.3; Derstein 2005.

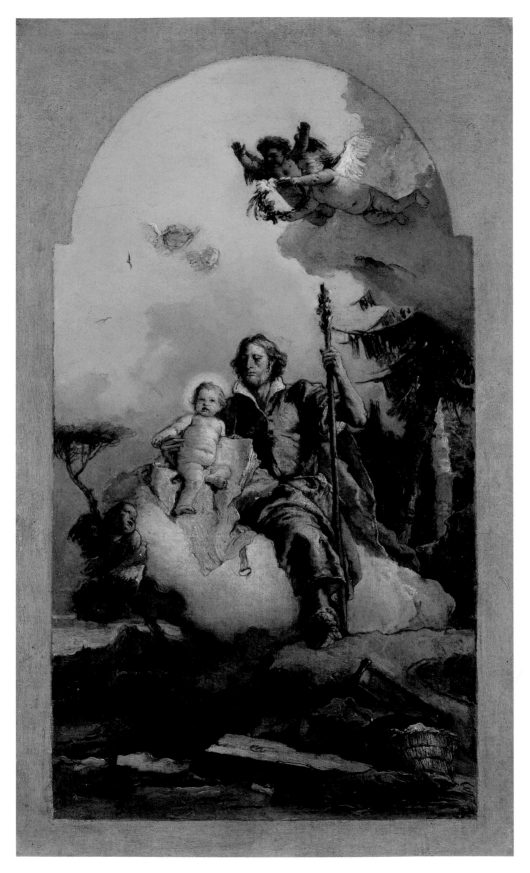

CAT. NO. 13A

CAT. NO. 13B

SAINT JOSEPH AND THE CHRIST CHILD sit atop a white cloud in a verdant landscape before a radiant blue sky. Firs and an encroaching cloud close off the composition on the right, while mountains appear far in the distance at lower left. Instruments of Joseph's profession as carpenter, including a saw and a plank of wood, lie prominently in the foreground, calling attention to Joseph's role as a craftsman and maker. Clad in a dark-buttoned cloak, Joseph holds his attribute, a flowering staff, upright, while supporting his son with the other arm. Seated on a bright yellow cloth, Christ leans on a book and turns his shoulder squarely to the picture plane, gazing out sweetly at the beholder. Meanwhile, Saint Joseph looks down on his child with a sense of foreboding, aware of his son's fate, as two putti rush in to crown the saint with a garland of white flowers.

Three fragments remain from the altarpiece, revealing the significant changes from the sketch. The largest, in the Detroit Institute of Arts, depicts Joseph with the Christ Child (fig. 13.1). A second fragment, taken from the upper reaches of the canvas, was separated into two parts in the early 1930s.[1] The left half of this fragment, depicting a putto carrying a garland of flowers, now survives in the Prado (fig. 13.2), while Antoine Seilern purchased the right half in 1959—the only instance in the Courtauld collection in which a sketch and finished composition can be compared. In addition, a squared drawing also survives (fig. 13.3), perhaps executed in preparation for a print either lost or never executed.[2]

All these works indicate that Tiepolo revised the treatment of *Saint Joseph with the Christ Child* far more radically than any of the other

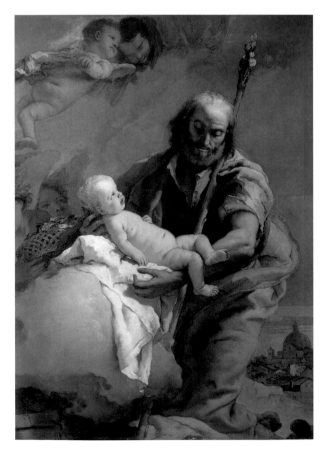

FIGURE 13.1 Giambattista Tiepolo. Fragment of *Saint Joseph with the Christ Child*, 1767–69. Oil on canvas. Detroit Institute of Arts, 44.213. Copyright © Detroit Institute of Arts.

FIGURE 13.2 Giambattista Tiepolo. Fragment of *Saint Joseph with the Christ Child*, 1767–69. Oil on canvas. Madrid, Museo Nacional del Prado. All rights reserved © Museo Nacional del Prado, Madrid.

paintings for San Pascual Baylon, transforming the sketch from the hieratic, almost iconic image into a tender and intimate composition—an unusual reversal of Tiepolo's customary progression from more intimate sketches to more formal final works. In the altarpiece, Joseph, now significantly older, holds the Christ Child in both arms, gently touching his infant's body. Instead of holding his shoulders square to the picture plane, Joseph torques inward, his stance emphasized by the staff that leans diagonally against his torso. Father and son look affectionately at one another, a loving parent-child relationship supplanting the grand, emotionally distant presentation originally conceived by Tiepolo.[3] He also considerably altered the landscape, making the cityscape much more prominent at left and emphasizing the basket, a reference to the Flight into Egypt and Joseph's role as protector of the Holy Family.

While the cult of Joseph grew considerably during the Counter-Reformation, the saint enjoyed particular popularity in Spain, demonstrated by his nomination in 1689 as official protector of the kingdom. His worship was encouraged especially by the Jesuits, Discalced Carmelites, and Franciscans, and the founder of the Alcantarines, Peter of Alcántara, wrote extensively on the saint, which explains his presence among the altarpieces of Aranjuez. Spanish artists—heavily influenced by the descriptions of Joseph in Jerónimo Gracián's *Sumario de las excelencias del glorioso San José* (1597) and Teresa of Ávila's *Libro de su vida* (1611)—began to represent the saint consistently as a young, vigorous figure. In the seventeenth century, Spanish clerics increasingly called for this type of representation, and guidelines from the Inquisition insisted on the youthful Joseph as late as the 1750s.[4] Tiepolo's sketch draws explicitly from this Spanish tradition, showing the saint with a full head of dark hair, a broad chest, and muscular forearms, the virile protector of Christ on earth.

By contrast, the altarpiece stresses the affective bonds between Joseph and Christ. The saint now appears as a significantly older, balding man, and in this way Tiepolo aligned the image with a broader, pan-European tradition of Joseph imagery that emerged in earnest during the Counter-Reformation. Coming out of the language of popular prints and devotional paint-

84

FIGURE 13.3 Copy after Giambattista Tiepolo. *Saint Joseph with the Christ Child*, ca. 1770–1805. Pen and ink on white paper. Vevey, Switzerland, Musée Jenisch. Photo: Claude Bornand, Lausanne.

ing, especially an influential prototype by Guido Reni (Museum of Fine Arts, Houston),[5] Tiepolo's altarpiece presents Joseph as a loving, demonstrative father.

Why Tiepolo made such a drastic change remains open to debate. No documents survive indicating whether Padre Joaquín de Eleta or another church official dictated the change or whether Tiepolo altered the composition on his own, nor has a second *modello* emerged.[6] The sketch certainly demonstrates Tiepolo's understanding of Spanish tradition (including a famous composition by Bartolomé Esteban Murillo

in Seville).[7] The final altarpiece surely came out of Tiepolo's sensitivity to the entire program at Aranjuez. He increased the personal, emotional pitch of the work, thus aligning its tone as well as its structure with the other altarpieces of male saints around the church. Rather than hold Saint Joseph apart from the surrounding visionary saints, Tiepolo placed him in formal and psychological harmony with the figures in the other altarpieces, further emphasizing the grandeur, nobility, and distinction of *The Immaculate Conception* (cat. no. 10).

Tiepolo painted the subject of Saint Joseph a number of times across his career and did not conform to a single stock representation. For example, in Tiepolo's Flight into Egypt variations —paintings the artist executed while at work on the Aranjuez sketches and altarpieces— the figure of Joseph appears in a wide variety of guises, from the youthful and active to the wizened and desiccated.[8] These *capricci* may even have served as a kind of laboratory for Tiepolo's depiction of Joseph, and the idea to change the altarpiece may in fact have derived from Tiepolo's experiments in these small pictures.

The scale of the fragment with the two cherubim heads, which matches that of the other Courtauld oil sketches, clearly convinced Count Antoine Seilern to incorporate it into his collection of *modelli*. The work also demonstrates how Tiepolo's larger paintings could retain the remarkably complex and subtle technique that characterizes the oil sketches. The cherubim in the fragment, to judge from the drawing in Vevey (fig. 13.3), appeared in the painting's upper reaches. The level of finish Tiepolo brought even to this relatively minor swath of canvas high up on a large altarpiece—intended to be viewed at a great distance—demonstrates the great care he and his studio lavished on these paintings. Moreover, the fragment shares the sophisticated and varied handling of the sketches. As might be expected, some passages are summary, particularly the thick, opaque strokes defining the fronds and the sketchy wet-on-wet passages of wings and hair. The loose application of blue in the sky reveals pinkish ground, which in turn gives a warm luminosity to the sky, passages which stand in notable contrast to the heavily impastoed clouds. On the other hand, the

faces of the putti are portrayed in a number of different ways: Tiepolo, for example, built up the sunlit forehead and open mouth of the cherub at left with thick layers of paint, and the delicate, gleaming lips of this figure come from the surprising application of transparent glazes. Two pentimenti further reveal Tiepolo's careful attention to this passage, for the clouds originally were raised much higher behind the heads.[9] ❧

NOTES

1 Morassi (1962, fig. 199) published a photograph of the larger fragment before its separation. A squared drawing in Vevey (fig. 13.3)—the only full record of the finished altarpiece—suggests that the halves came from different sections of the composition and were later stitched together, possibly in the early twentieth century. No records survive about the separation of the two parts, but conservation treatment conducted after Count Antoine Seilern acquired the right fragment revealed that the putti were nestled among the evergreens and that the branches had been overpainted as sky. See Seilern 1971b, 67.

2 George Knox (1980, 1:74, 194) attributed this drawing to Tiepolo's son, Giandomenico. Andria Derstein, however, rightly questions this attribution and has provided the most useful analysis of the puzzling work (Derstein 2005).

3 For the Detroit fragment, see Derstein 2005.

4 On the Spanish tradition, see especially the work of Charlene Villaseñor Black, including "Saints and Social Welfare in Golden Age Spain," Ph.D. diss., University of Michigan, 1995, and "Matrimony and Gender Discourses in Seventeenth-Century Spain," *Sixteenth-Century Studies* 32, no. 3 (2001): 637–68; as well as Christopher Chadwick Wilson, "St. Teresa of Ávila's Holy Patron: Teresian Sources for the Image of St. Joseph in Spanish American Colonial Art," in *Patron Saint of the New World: Spanish American Colonial Images of St. Joseph*, edited by Joseph F. Chorpenning (Philadelphia: Saint Joseph's University Press, 1992).

5 D. Stephen Pepper, *Guido Reni: A Complete Catalogue of His Work with an Introductory Text* (New York: New York University Press, 1984): 285–86.

6 Whistler (1998, 76) has suggested that the change in age came from Tiepolo's interest in distinguishing Joseph from Anthony of Padua in the painting originally mounted across the nave (see fig. 1, p. 60).

7 The typology of Joseph with the standing Christ Child also had a precedent in Tiepolo's own oeuvre, appearing in the ca. 1732 altarpiece *Saint Joseph with the Christ Child with Saints Francis di Paola, Anna, Anthony Abbot, and Peter of Alcántara*, painted for the Church of San Prosdocimo in Padua, and now in the Galleria dell'Accademia, Venice (Pedrocco 2002, 224).

8 Christiansen 1996, 338–43.

9 See the reports by Candy Kuhl in the conservation files of the Courtauld Institute of Art.

Exhibitions and Literature Cited

Exhibitions Cited

FORT WORTH 1993
Giambattista Tiepolo: Master of the Oil Sketch. Kimbell Art Museum, Fort Worth, September 18– December 12, 1993.

LONDON 1954–55
European Masters of the Eighteenth Century. Royal Academy of Arts, London, November 27, 1954–February 27, 1955.

LONDON 1960
Italian Art and Britain. Royal Academy of Arts, London, January 2–March 6, 1960.

LONDON 1963–64
Goya and His Times. Royal Academy of Arts, London, December 7, 1963–March 1, 1964.

LONDON 1984
Thirty-five Paintings from the Collection of the British Rail Pension Fund. Thomas Agnew's and Sons, London, November 8– December 14, 1984.

LONDON 1989
Painting in Spain during the Later Eighteenth Century. National Gallery, London, 1989.

LONDON AND BIRMINGHAM 1951
Eighteenth Century Venice. Whitechapel Art Gallery, London, January 3–March 14, 1951; Museum and Art Gallery, Birmingham, March 21– April 18, 1951.

VENICE 1951
Mostra di Giambattista Tiepolo. Ca' Rezzonico, Venice, June 16–October 7, 1951.

VENICE AND NEW YORK 1996
Giambattista Tiepolo, 1696–1770. Museo del Settecento veneziano, Ca' Rezzonico, Venice, September 5–December 9, 1996; Metropolitan Museum of Art, New York, January 22–April 27, 1997.

VIENNA 1937
Italienische Barockmalerei. Galerie Sanct Lucas, Vienna, May 14–June 15, 1937.

Literature Cited

AIKEMA 1986
Aikema, Bernard. "Nicolò Bambini e Giambattista Tiepolo nel salone di Palazzo Sandi a Venezia." *Arte veneta* 40 (1986): 167–71.

ALPERS AND BAXANDALL 1994
Alpers, Svetlana, and Michael Baxandall. *Tiepolo and the Pictorial Intelligence.* New Haven: Yale University Press, 1994.

BALDINUCCI 1681
Baldinucci, Filippo. *Vocabolario toscano dell'arte del disegno . . .* Florence: Per Santi Franchi al segno della passione, 1681.

BARCHAM 1979
Barcham, William L. "Giambattista Tiepolo's Ceiling for S. Maria di Nazareth in Venice: Legend, Traditions, and Devotions." *Art Bulletin* 61 (1979): 430–47.

BARCHAM 1989
Barcham, William L. *The Religious Paintings of Giambattista Tiepolo: Piety and Tradition in Eighteenth-Century Venice.* Oxford: Clarendon Press, 1989.

BARCHAM 1992
Barcham, William L. *Giambattista Tiepolo.* New York: Harry N. Abrams, 1992.

BAUER 1975
Bauer, Linda Freeman. "On the Origins of the Oil Sketch: Form and Function in Cinquecento Preparatory Techniques." Ph.D. diss., New York University, 1975.

BAUER AND BAUER 1999
Bauer, Linda, and George Bauer. "Artists' Inventories and the Language of the Oil Sketch." *Burlington Magazine* 141, no. 1158 (September 1999): 520–30.

BOTTARI AND TICOZZI 1822
Bottari, M. Giovanni, and Stefano Ticozzi. *Raccolta di lettere sulla pittura, scultura, ed architettura scritte da' più celebri personaggi dei secoli XV, XVI, e XVII.* Vol. 4. Milan: Silvestri, 1822.

BOWRON AND RISHEL 2000
Bowron, Edgar Peters, and Joseph J. Rishel, eds. *Art in Rome in the Eighteenth Century.* Exhibition catalogue. London: Merrell, 2000.

BRADFORD AND BRAHAM 1989
Bradford, William and Helen Braham. *Checklist of Paintings: University of London.* London: Courtauld Institute Galleries, 1989.

BRAHAM 1981
Braham, Helen. *The Princes Gate Collection.* Exhibition catalogue. London: Trustees of the Home House Society for the Courtauld Institute of Art, 1981.

BROWN 1993
Brown, Beverly Louise, ed. *Giambattista Tiepolo: Master of the Oil Sketch.* Exhibition catalogue. Milan: Electa; New York: Abbeville, 1993.

BRUNEL 1991
Brunel, Georges. *Tiepolo.* Mensil-sur-l'Estrée: Fayard, 1991.

CHRISTIANSEN 1996
Christiansen, Keith, ed. *Giambattista Tiepolo, 1696–1770.* Exhibition catalogue. New York: Metropolitan Museum of Art, 1996.

CHRISTIANSEN 1999
Christiansen, Keith. "Tiepolo, Theater, and the Notion of Theatricality." *Art Bulletin* 71 (December 1999): 665–92.

COLETTI 1936
Coletti, Luigi. "Zwei Entwürfe von Tiepolo." *Pantheon* (May 1936): 170–71.

CONISBEE, LEVKOFF, AND RAND 1991
Conisbee, Philip, Mary L. Levkoff, and Richard Rand. *The Ahmanson Gifts: European Masterpieces in the Collection of the Los Angeles County Museum of Art.* Los Angeles County Museum of Art, 1991.

CRIVELLATO 1960
Crivellato, Valentino. *Tiepolo.* Bergamo: Istituto italiano d'arti grafiche, 1960.

CRIVELLATO 1962
Crivellato, Valentino. *Tiepolo.* Translation by Anthony Rhodes. New York: W. W. Norton, 1962.

CUNO 2003
Cuno, James, *Peter Paul Rubens: A Touch of Brilliance: Oil Sketches and Related Works from the Collection of the State Hermitage Museum/Courtauld Institute.* Exhibition catalogue. London: Prestel, 2003.

DAZZI 1951
Dazzi, Manilio Torquato. "Scheda per il procuratore di G. B. Tiepolo." *Arte veneta,* 17–20 (1951): 178–85.

DERSTEIN 2005
Bissell, R. Ward, Dwight Miller, and Andria Derstein. *Masters of Italian Baroque Painting: The Detroit Institute of Arts.* Detroit: GILES in association with the Detroit Institute of Arts, 2005.

FARR 1987
Farr, Dennis, ed. *One Hundred Masterpieces from the Courtauld Collections: Bernardo Daddi to Ben Nicholson; European Paintings and Drawings from the Fourteenth to the Twentieth Century.* London: Courtauld Institute of Art Fund, 1987.

FARR, BRADFORD, and BRAHAM 1990
Farr, Dennis, William Bradford, and Helen Braham. *The Courtauld Galleries. University of London.* London: Scala, 1990.

FERRARI 1993
Ferrari, Oreste. "The Development of the Oil Sketch in Italy." In *Giambattista Tiepolo: Master of the Oil Sketch,* edited by Beverly Louise Brown, 42–63. Exhibition catalogue. Milan: Electa; New York: Abbeville, 1993.

FIOCCO 1938
Fiocco, Giuseppe. "An Early Work by Giambattista Tiepolo." *Art in America* 26 (1938): 147–57.

FIOCCO 1942
Fiocco, Giuseppe. "Tiepolo in Spagna." *Le arti* 5, no. 1 (October 29, 1942): 7–10.

FOLGOLARI 1931
Folgolari, Gino. "Il bozzetto del Tiepolo per il trasporto della Santa Casa di Loreto." *Bollettino d'arte,* ser. 3, 25, no. 1 (July 1931): 18 32.

FREDERICKSEN 1995
Fredericksen, Burton B., ed. *Masterpieces of Painting in the J. Paul Getty Museum,* 3d ed. Malibu: J. Paul Getty Museum, 1995.

GAYA NUÑO 1964
Gaya Nuño, Juan Antonio. *Pintura europea perdida por España, de Van Eyck a Tiépolo.* Madrid: Espasa-Calpe, 1964.

GEMIN AND PEDROCCO 1993
Gemin, Massimo, and Filippo Pedrocco. *Giambattista Tiepolo: I dipinti, opera completa.* Venice: Arsenale, 1993.

GIAMBATTISTA TIEPOLO 1998
Giambattista Tiepolo, 1696–1770. Exhibition catalogue. Paris: Paris-Musées, 1998.

HEINE 1974
Heine, Barbara. "Tiepolos Dreifaltigskeitbild in der Klosterkirche zu Nymphenberg." *Pantheon* 32 (1974): 144–52.

HELD 1980
Held, Julius S. *The Oil Sketches of Peter Paul Rubens: A Critical Catalogue.* 2 vols. Princeton: Princeton University Press, 1980.

HELSTON 1989
Helston, Michael. *Painting in Spain during the Later Eighteenth Century.* Exhibition catalogue. London: National Gallery, 1989.

JAFFÉ 1997
Jaffé, David. *Summary Catalogue of European Paintings in the J. Paul Getty Museum.* Los Angeles: J. Paul Getty Museum, 1997.

KNOX 1955
Knox, George. "Venetian History Painters of the Settecento." *Connoisseur* 135 (March 1955): 29–39.

KNOX 1963
Knox, George. "The Paintings by G. B. Tiepolo." *Burlington Magazine* 105, no. 724 (July 1963): 327–28.

KNOX 1968
Knox, George. "G. B. Tiepolo and the Ceiling of the Scalzi." *Burlington Magazine* 110, no. 784 (July 1968): 394–400.

KNOX 1970
Knox, George. *Tiepolo: A Bicentenary Exhibition, 1770–1970. Drawings, Mainly from American Collections, by Giambattista Tiepolo and the Members of His Circle.* Exhibition catalogue. Cambridge, MA: Fogg Art Museum, Harvard University, 1970.

KNOX 1980
Knox, George. *Giambattista and Domenico Tiepolo: A Study and Catalogue Raisonné of the Chalk Drawings.* 2 vols. Oxford: Clarendon Press, 1980.

KNOX 1993
Knox, George. "Ca' Sandi: La forza della eloquenza." *Arte/Documento* 7 (1993): 135–45.

LEVEY 1959
Levey, Michael. *Painting in Eighteenth-Century Venice.* London: Phaidon Press, 1959.

LEVEY 1960a
Levey, Michael. "Count Seilern's Italian Pictures and Drawings." *Burlington Magazine* 102, no. 684 (March 1960): 122–23.

LEVEY 1960b
Levey, Michael. "Two Paintings by Tiepolo from the Algarotti Collection." *Burlington Magazine* 102, no. 687 (June 1960): 250–53.

LEVEY 1971
Levey, Michael. *National Gallery Catalogues: The Seventeenth- and Eighteenth-Century Italian Schools.* London: National Gallery, 1971.

LEVEY 1980
Levey, Michael. *Painting in Eighteenth-Century Venice.* Revised 2d ed. Ithaca, NY: Cornell University Press, 1980.

LEVEY 1986
Levey, Michael. *Giambattista Tiepolo: His Life and Art.* New Haven: Yale University Press, 1986.

LEVEY 1994
Levey, Michael. *Giambattista Tiepolo: His Life and Art.* Reprint with corrections. New Haven: Yale University Press, 1994.

LORENZETTI 1951
Lorenzetti, Giulio. *Mostra del Tiepolo: Catologo ufficiale.* Exhibition catalogue. Venice: Alfieri, 1951.

MARINI 1998
Marini, Giorgio. "Novità per Lorenzo Tiepolo incisore." In *Giambattista Tiepolo nel terzo centenario della nascita: Atti del Convegno internazionale di studi, Venezia, Vicenza, Udine, Parigi, 29 ottobre–4 novembre 1996,* edited by Lionello Puppi. 2 vols. Quaderni di Venezia arti, 4. Venice: Università Ca' Foscari di Venezia, 1998: 1:99–104.

MARTINI 1988
Martini, Egidio. "Un'opera giovanile di Giambattista Tiepolo." *Arte veneta* 42 (1988): 152–54.

MAYER 1935
Mayer, Augusto L. "Dos bocetras de Juan Bautista Tiépolo." *Revista española de arte* 4 (1935): 300–309.

MORASSI 1938
Morassi, Antonio. "Yet More about the Young Tiepolo." *Burlington Magazine* 73, no. 427 (October 1938): 141–42.

MORASSI 1943
Morassi, Antonio. *Tiepolo.* Bergamo: Istituto italiano d'arte grafiche, 1943.

MORASSI 1950
Morassi, Antonio. "Nuovi inediti del Tiepolo." *Emporium* 112, no. 671 (November 1950): 195–209.

MORASSI 1955a
Morassi, Antonio. *G. B. Tiepolo: His Life and Work.* Translated by Dr. and Mrs. Peter Murray. New York: Phaidon, 1955.

MORASSI 1955b
Morassi, Antonio. "Some 'Modelli' and Other Unpublished Works by Tiepolo." *Burlington Magazine* 97, no. 622 (January 1955): 4–12.

MORASSI 1957
Morassi, Antonio. "I quadri veneti del Settecento nella riaperta 'Alte Pinakothek' di Monaco." *Arte veneta* 11 (1957): 173–80.

MORASSI 1962
Morassi, Antonio. *A Complete Catalogue of the Paintings of G. B. Tiepolo, Including Pictures by His Pupils and Followers Wrongly Attributed to Him.* Translated by Dr. and Mrs. Peter Murray. London: Phaidon Press, 1962.

MRAS 1956
Mras, George P. "Some Drawings by G. B. Tiepolo." *Record of the Art Museum, Princeton University* 15, no. 2 (1956): 39–59.

PALLUCCHINI 1951
Pallucchini, Rodolfo. *Lezioni de storia dell'arte. La pittura veneziana del Settecento.* Bologna: Riccardo Pàtron, 1951.

PALLUCCHINI 1960
Pallucchini, Rodolfo. *La pittura veneziana del Settecento.* Venice: Istituto per la collaborazione culturale, 1960.

PAVANELLO 1996
Pavanello, Giuseppe. *Canova collezionista di Tiepolo.* Monfalcone: Edizioni della Laguna, 1996.

PEDROCCO 2002
Pedrocco, Filippo. *Giambattista Tiepolo*. Milan: Rizzoli libri illustrati, 2002.

PIGNATTI 1951
Pignatti, Terisio. *Tiepolo*. Verona: Mondadori, 1951.

PIOVENE AND PALLUCCHINI 1968
Piovene, Guido, and Anna Pallucchini. *L'opera completa di Giambattista Tiepolo*. Classici dell'arte, 25. Milan: Rizzoli, 1968.

PUPPI 1998
Puppi, Lionello, ed. *Giambattista Tiepolo nel terzo centenario della nascita: Atti del Convegno internazionale di studi, Venezia, Vincenza, Udine, Parigi, 29 ottobre–4 novembre 1996*. 2 vols. Quaderni di Venezia Arti, 4. Venice: Università Ca'Foscari di Venezia, 1998.

RIZZI 1971
Rizzi, Aldo, ed. *Mostra del Tiepolo*. 2 vols. Exhibition catalogue. Milan: Electa, 1971.

ROSA 1999
Rosa, Mario. *Settecento religioso: Politica della ragione e religione del cuore*. Venice: Marsilio, 1999.

ROSSACHER 1965
Rossacher, Kurt. *Visionen des Barock: Entwürfe aus der Sammlung Kurt Rossacher*. Exhibition catalogue. Darmstadt: Hessisches Landesmuseum, 1965.

ROSSACHER 1968
Rossacher, Kurt. *Images and Imagination: Oil Sketches of the Baroque. Collection Kurt Rossacher*. Exhibition catalogue. Los Angeles: Los Angeles County Museum of Art, 1968.

SACK 1910
Sack, Eduard. *Giambattista und Domenico Tiepolo: Ihr Leben und ihre Werke: Ein Beitrag zur Kunstgeschichte des achtzehnten Jahrhunderts*. Hamburg: Clarmanns, 1910.

SALTILLO 1952
Saltillo, Miguel Lasso de la Vega y López de Tejada, marqués del. "Goya en Madrid: Su familia y allegados (1746–1856)." *Miscelanea madrileña, historica y artistica*, first series. Madrid: Maestre, 1952.

SÁNCHEZ CANTÓN 1949
Sánchez Cantón, F. J. *Museo del Prado. Catálogo de los cuadros*. Madrid: Museo del Prado, 1949.

SÁNCHEZ CANTÓN 1953
Sánchez Cantón, F. J. *J. B. Tiepolo en España*. Madrid: Instituto Diego Velázquez, 1953.

SCIRÈ NEPI 1991
Scirè Nepi, Giovanna. *Treasures of Venetian Painting: The Gallerie dell'Accademia*. London: Thames and Hudson, 1991.

SEILERN 1959
Seilern, Antoine. *Italian Paintings and Drawings at 56 Princes Gate London SW7*. 2 vols. London: Shenval Press, 1959.

SEILERN 1969
Seilern, Antoine. *Italian Paintings and Drawings at 56 Princes Gate London SW7: Addenda*. 2 vols. London: Shenval Press, 1969.

SEILERN 1971a
Seilern, Antoine. *Corrigenda and Addenda to the Catalogue of Paintings and Drawing at 56 Princes Gate London SW7*. London: Shenval Press, 1971.

SEILERN 1971b
Seilern, Antoine. *Recent Acquisitions at 56 Princes Gate London SW7*. London: Shenval Press, 1971.

SOHM 1984
Sohm, Philip L. "Giambattista Tiepolo at the Palazzo Archinto in Milan." *Arte lombarda*, n.s., no. 1–2 (1984): 70–78.

SOTHEBY'S 1975
"Sotheby's: Sales in December." *Burlington Magazine* 117, no. 863 (February 1975): i–ii.

SPIKE 1993
Spike, John T. *Italian Paintings in the Cincinnati Art Museum*. Cincinnati Art Museum, 1993.

THIEME-BECKER 1939
Thieme, Ulrich, and Felix Becker. *Allgemeines Lexikon der bildenden Künstler von der Antike bis zur Gegenwart*. 37 vols. Leipzig: E. A. Seemann, 1907–50.

VENICE 1952
Venice 1700–1800. Exhibition catalogue. Detroit: Detroit Institute of Arts, 1952.

VIGNI 1951
Vigni, Giorgio. *Tiepolo*. Milan: Electa, 1951.

WATSON 1952
Watson, Francis. "Reflections on the Tiepolo Exhibition." *Burlington Magazine* 94, no. 586 (February 1952): 40–44.

WATSON 1955
Watson, Francis. "Venetian Painting at the Royal Academy, 1954–55." *Arte veneta* 9 (1955): 253–64.

WATSON 1963
Watson, Francis. Review of *A Complete Catalogue of the Paintings of G. B. Tiepolo, Including Pictures by His Pupils and Followers Wrongly Attributed to Him* by Antonio Morassi. *Apollo* 77 (March 1963): 244–48.

WESCHER 1960
Wescher, Paul. *La prima idea: Die Entwicklung der Ölskizze von Tintoretto bis Picasso*. Munich: Bruckmann, 1960.

WHISTLER 1984
Whistler, Catherine. "Giambattista Tiepolo in Spain: The Late Religious Paintings." Ph.D. diss., University College Dublin, National University of Ireland, 1984.

WHISTLER 1985a
Whistler, Catherine. "A *Modello* for Tiepolo's Final Commission: *The Allegory of the Immaculate Conception.*" *Apollo* (March 1985): 172–73.

WHISTLER 1985b
Whistler, Catherine. "G. B. Tiepolo and Charles III: The Church of S. Pascual Baylon at Aranjuez." *Apollo* 121 (May 1985): 321–37.

WHISTLER 1986
Whistler, Catherine. "G. B. Tiepolo at the Court of Charles III." *Burlington Magazine* 128, no. 996 (March 1986): 199–204.

WHISTLER 1995
Whistler, Catherine. Review of *Giambattista Tiepolo, i dipinti, opera completa* by Massimo Gemin and Filippo Pedrocco. *Burlington Magazine* 137, no. 1110 (September 1995): 625–27.

WHISTLER 1998
Whistler, Catherine. "Decoro e devozione nelle pale di Giambattista Tiepolo ad Aranjuez." *Arte veneta* 52 (1998): 70–85.

ZAMPETTI 1969
Zampetti, Pietro. *Dal Ricci al Tiepolo: I pittori di figura del Settecento a Venezia.* Exhibition catalogue. Venice: Alfieri, 1969.

Index